JACKETS REQUIRED

JACKETS REQUIRED

Steven Heller
Seymour Chwast

CHRONICLE BOOKS

SAN FRANCISCO

ACKNOWLEDGMENTS

The authors sincerely thank Glenn Horowitz of Glenn Horowitz Bookseller, New York City, for sharing his expert advice and supplying many of the exquisite jackets used in this book. Others who loaned material for this book are Piet Schreuders, William Drenttel, Elaine Lustig Cohen, Paul Rand, James Fraser, Richard Samuel West, Steven Guarnaccia, Leslie Cabarga, Gina Davis, and Mirko Ilic. Thanks also to Robert and Dorothy Emerson of R & D Emerson Books, Falls Village, Connecticut; Irving Oaklander of Oaklander Books, New York City; and Barbara Cohen, New York Bound Bookshop, New York City; for their assistance. And thanks to Ben Feder for his memories and insight.

We express gratitude to our editor Bill LeBlond, art director Michael Carabetta, and assistant editor Leslie Jonath at Chronicle Books for their support and hard work on behalf of this project. We appreciate all that our designer, Roxanne Slimak at the Pushpin Group, did in keeping this book on track, thanks also to Edward Spiro for additional photography, Harriet Chua for production assistance, and Sarah Jane Freymann for being our agent.

CREDITS

Glenn Horowitz: 23 (top left), 28 (top left and right), 30 (bottom middle), 44 (right), 47 (right), 49 (bottom left), 57 (right), 63 (top right), 67, 69 (top right), 70 (top left, bottom right and left), 74 (top right, bottom right), 75, 85 (middle left and middle), 86 (right), 90 (bottom left), 104 (left and bottom right), 108, 112.

Collection of Barbara Cohen: 28 (bottom left).

University of Virginia Library: 32 (left, top right), 122, 123.

Fairleigh Dickinson University Library, Madison Campus: 38 (right top).

Mirko Ilic: 49 (top left), 52, 78 (top left), 88 (bottom), 97, 113 (bottom right).

William Drenttel: 65.

Leslie Cabarga: 71.

Richard Samuel West: 107 (left).

Gina Davis: 121.

Piet Schreuders: 125, 126, 127, 128.

Elaine Lustig Cohen: 130, 131, 132, 133, 134 (left), 136 (right).

Paul Rand: 137, 138, 139.

Library of Congress Cataloging-in-Publication Data available.

Printed in Hong Kong.

ISBN 0-8118-0396-1

Distributed in Canada by Raincoast Books, 8680 Cambie Street, Vancouver, B.C. V6P 6M9

10 9 8 7 6 5 4 3 2 1

CHRONICLE BOOKS
275 FIFTH STREET
SAN FRANCISCO, CA 94103

TABLE OF CONTENTS

"A collection of contemporary book jackets serves as a barometer of interest and taste. One can easily imagine a scholar of a hundred years hence poring over them with fascination. They will carry the flavor of our age as effectively as the Victorian valentines or the early English chapbooks do theirs."

–Henry F. Pits,
American Book Illustration, 1930.

A cover is the permanent binding of a hardcover book. It is plain except for the title and author's name embossed on the front and spine. The jacket is the separate paper wrapper that protects the cover and is printed with words and images that evoke—and promote—the contents of a book. Yet many who design books call the jacket an unwanted appendage. They reason that the cover is both the book's skeleton and skin; without it there is no book. The jacket, on the other hand, is the book's clothing; while it may be fashionable—indeed seductive—without it the book continues to function perfectly. The cover is integral. The jacket, although functional, is ephemeral. The cover will last for the life of the book, whereas the jacket is often removed after it is taken home.

Yet unlike a cover, you can tell a book by its jacket —sometimes. As the statement by the book jacket artist Henry F. Pits suggests, through its distinctive graphic styling, the jacket, not the cover, is an indicator of popular culture. Although the great books are not remembered for their outerwear but rather their inner meaning, Pits contends that the jacket provides a clue, if not the evidence, of how tastes and fashions ebb and flow—and how this affects the way books are promoted, marketed, and ultimately perceived by the general public.

A jacket might very well chart the development of a new book on its way to becoming popular. Not all best-sellers start out as such, and jacket graphics suggest the commercial uncertainties of the publishing industry. If a publisher is not confident that a specific book will reach its intended audience—or is vague about who that audience might be—the jacket image will often be generic, having little or no relationship to the content of the book. On the other hand, if the publisher understands his market, the imagery might explicitly depict the characters or a key scene if it is believed that such an overt visual narrative will pique reader interest. The various images and typographic styles used to depict a book's content reveal more about marketing strategy than literary quality, yet when they are studied as examples of popular art, book jackets are signposts of a period's aesthetics.

In America book jacket designs from the 1920s, '30s, and '40s have been virtually ignored, yet they are artistic treasures every bit as endemic to this modern visual culture as are the great *affiches* from 1920s and '30s France, Germany, and Italy to the history of European graphic communications. Although America had a vigorous poster industry at that time and an indigenous poster format (the 24-sheet billboard), stylistic innovation was not one of its hallmarks. In fact, the American advertising poster from the turn of the century was rather prosaic. In contrast, book jackets emerged as one of America's more vital graphic media and became a proving ground for eccentric design. Owing to its scale, the book jacket, essentially a miniposter, was

dependent on striking visuals and bold lettering or typography for visibility in the marketplace.

In the 1920s and '30s book jackets had to compete with magazine covers, which at that time were enjoying a golden age of creativity. Many of America's most virtuosic illustrators and graphic designers—including some of the great magazine cover artists—were recruited by the leading publishing houses, for it was assumed that their eye-catching graphics would stimulate interest in and demand for books of all kinds. Visionary publishing firms, such as Boni and Liveright and Alfred A. Knopf, developed house graphic styles through tempting jacket art and design. Booksellers were encouraged to give precious window space to those books with jackets that demanded attention. Success begat imitation, and soon many American trade publishers were dressing their fiction, and nonfiction to a lesser degree, in appealing jackets.

This creative surge coincided with the acceptance of *art moderne* or Art Deco —the commercialization of Modern Art—as a universal graphic style. Cubistic, Modernistic, and streamlined ornament, characterized by rectilinear geometries, ziggurats, lightning bolts, and other ornamental novelties, was inspired both by orthodox European Modern Art (i.e., Futurism, Bauhaus, de Stijl, and Constructivism) and by artifacts rediscovered from antiquity that were incorporated into a visual style devoid of any of the progressive movements' philosophical overtones. *Art moderne* both influenced and reflected a growing interest in progress and modernity underscored by the Machine Age ethos.

As a marketing tool *art moderne* did not, however, always sit well with the venerable book publishers whose roots dug deep into nineteenth-century tradition, and who rejected *au courant* marketing and advertising approaches as long as they could. But by the 1920s the majority of trade publishers were compelled by competition from magazines, radio, movies, and an increasing number of new publishing houses to reconcile themselves to vigorous marketing strategies. To relax the strictures imposed by antiquated aesthetics, book jacket designers aggressively borrowed from *art moderne* and developed new styles that signaled contemporaneity. Classical and neoclassical forms were modernized and streamlined in what became a typically modernistic mannerism. New veneers were given to old favorites. New best-sellers were contemporary to a fault. The most eye-catching jackets were those in which the popular graphic style, admittedly often gaudy, thoroughly dominated. Yet any relationship between these stylized jackets and a book's conservative interior design was purely coincidence. Rarely did the same person design both the book and the jacket, a convention that continues today. And the dichotomy between contemporary and classic approaches caused a rift between commercial jacket and purist book designers.

Traditional bookmakers viewed jackets as sullying the excellence of an otherwise well-made book. In fact, most jackets were designed without even the slightest regard for the book's typographic structure. Even when the jacket and book designer were one in the same, the image and lettering on the jacket were not in harmony with the composition of the book. It is nonetheless curious that while book designers resented the separation of labor, many were unwilling

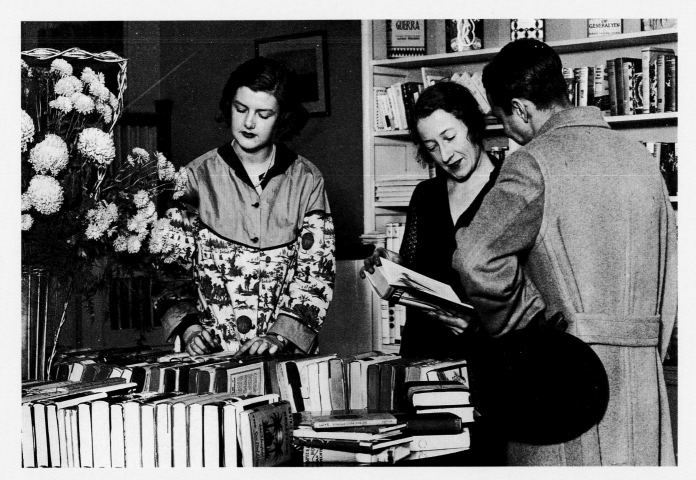

to dirty their hands with such superficial work. As late as the 1950s the jacket was still thought of as merely advertising. The prestigious annual American Institute of Graphic Arts (AIGA) "Fifty Books Show" adamantly refused to exhibit jackets or even mount its own book jacket show. In response, book jacket designers founded the Book Jacket Designers Guild in 1947 to celebrate their own accomplishments. (It ceased six years later owing to rivalries between members.) In the catalog for *Books of Our Times*, an exhibition of the most progressively designed books of the 1940s and early '50s, book designer Marshall Lee wrote: "It could be argued that the jacket is part of the book, but the [selection] Committee feels that this is a temporary and fallacious point of view. One need only to consider the absurdity of having one expensive cover designed that will permanently conceal another! Either the jacket is a temporary protection and sales device, meant to be torn from the book the moment it is sold, or it is an indispensable cover. If the latter were true, the logical procedure would be to dispense with the costly, unseen binding design. The jacket then becomes the binding, and the function of both binding and jacket will be the same."

That the book jacket was not considered integral to the art and craft of bookmaking had its genesis during the *fin de siècle* with the Aesthetic Movement, a loosely affiliated group of craft-oriented designers who believed that the design of fine bindings was the ultimate aesthetic virtue. Bibliophiles also

The bookshop as meeting place and repository of ideas.

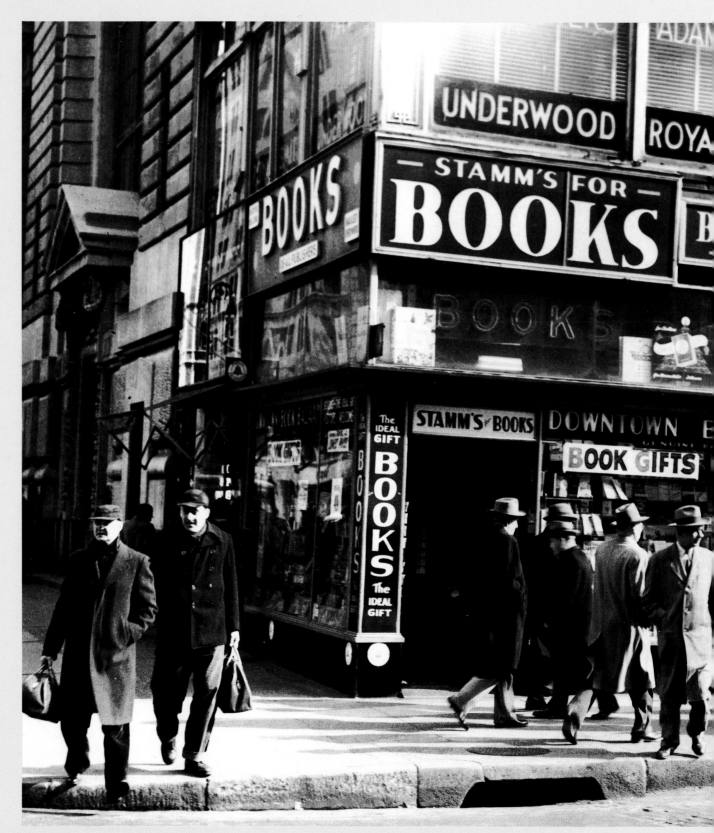

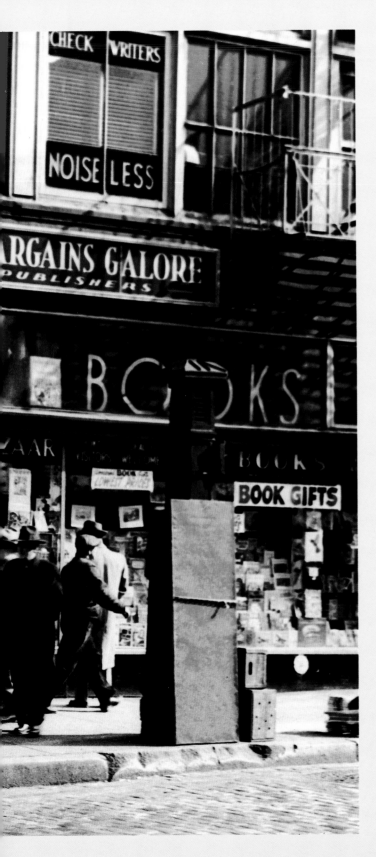

treasured books for the quality of their craftsmanship based on classical standards and refused to accept jackets as anything more than a cheap wrapper. And why not? Decades earlier the jacket was invented to be discarded.

When introduced in 1833 by the English publisher Longmans & Co., the dust wrapper, as it was commonly referred to, was used exclusively to protect a book's exposed leather, cloth, or silk bindings from the smut and fog that blanketed London. Prior to the dust wrapper, "temporary bindings" shielded books either with cardboard covers or loosely wrapped paper. But these devices made it rather difficult to browse through the book in the shop, and so a more accessible covering was needed. According to the pioneer jacket designer George Salter, who wrote the introduction to the catalog for *The Exhibition of the Book Jacket Designers Guild 1949*, "[these temporary bindings] may have taken on features similar to those of a book jacket," but the dedicated jacket was a long way from being accepted.

The earliest dust wrappers were packages made of thin kraft paper in shades of brown, gray, or blue that covered all sides of the book. Initially the author's name was written or stamped on the front for identification, and eventually small windows were cut through the paper exposing the title or author's name on the cover. Some windows were covered with transparent glassine. This "package-style" wrapper was eventually modified to allow for easier inspection. The successor to the package was the jacket format with flaps tucked around the binding similar to what is commonly used today. But the idea that a jacket had any aesthetic, or even promotional, potential was ignored until after the turn of the century. 11

Illustration was introduced on jackets in the second half of the nineteenth century but was not widely used until the end of the century. Originally black silhouettes were stamped onto the kraft paper; later two-color printing became the standard. During the 1890s some publishers embossed illustrations directly onto their covers and often that same image would be printed on the dust wrapper in one or two colors. On occasion visionary publishers engaged celebrated *graphistes* such as Aubrey Beardsley, Henri Toulouse-Lautrec, Alexandre Theofiles Steinlen, and Emil Orlik to render original images. But even this feat did not completely influence publishers that artwork had certain advantages to plain jackets. "The physical make-up of these jackets," wrote George Salter, "differed from that of today's jackets in nothing but the prevailing style, but their time had not come yet." Despite these innovations, the staid, unpretentious wrapper continued into the early 1900s when, according to Salter, "the metamorphosis of the wrapper into the jacket finally took place." The key to this revolutionary change was, however, neither art nor design but a new promotional gimmick called a "blurb."

The earliest known blurb, a brief testimonial that claims every book published is the "finest on the subject that has ever been written," has been traced back to around 1910 and has been a fixture on jackets (and paperback covers) ever since. In addition to blurbs, publishers also used jackets to promote their other books, often in lists on the back covers. The flaps became a perfect venue for short paragraphs, or ad copy, that synopsized and/or celebrated the book in such a way that browsers would receive a tempting sampling of its contents. Publishers agreed that this, more than advertising, was the most effective means to establish contact with the reading public. But as Salter points out, "The front of the jacket, not the least important part, at last became an area of graphic design which began to assume its real position as a force of display and advertising."

Bookmaking had not changed much from Guttenberg to the 1930s.

In 1933, as the Great Depression dragged on, Helen Dryden, an illustrator and contributor to *Advertising Arts*, the leading graphic design trade magazine, wrote: "A bookseller's window is now one of the gayest sights, next to florists', these sad times afford." By then books were in fierce competition with movies, and few trade books were published without illustrative jackets. Yet some publishers and design-ers continued to view them as a necessary evil rather than a challenging opportunity. Nevertheless, the *Publisher's Weekly* touted the industry and devoted frequent articles to the aesthetic and commercial merits and demerits of important jackets. By the 1930s this kind of publicity helped legitimize and ultimately aid in developing a small, though viable, profession of book jacket designers. Dryden noted

13

that "now every book is fast becoming a poster for itself No doubt this is one of the reasons why half the windows in town seem to be filled with books these days and all the world is in danger of becoming literate." Despite this newfound success, however, many of the jacket artists were anonymous because some publishing houses prohibited artists from having signatures or credit lines. Their reasoning was that jackets were packages not artworks.

Anonymous or not, a small group of book jacket design specialists began to emerge that practiced varied approaches and methods: Some were true to one specific style, while others adapted differently to each job. Together they formed an indigenous American style that developed a character distinct from Europe, where the reading public was not as bombarded by competing media, and so books were generally easier to sell there. American jackets were treated individually. European jackets (as well as paperback covers) were often designed in consistently formatted series. That Europeans favored consistency mirrored their reading habits, which were based on loyalty to specific authors and publishers. Americans were, on the whole, not as loyal and would buy whatever was popular (or appeared

The jacket as mini-poster

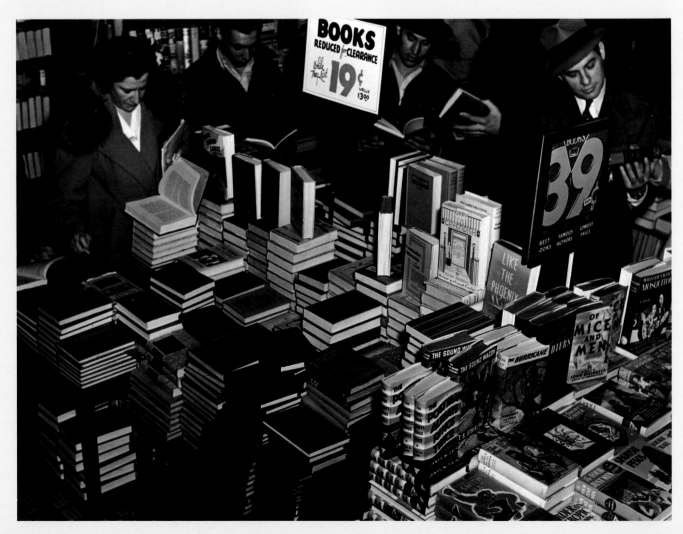

to be), which contributed to the best-seller mentality that has had a long-term effect on jacket design conventions and taboos.

Bright colors, stylized motifs, block lettering (usually hand drawn and printed in black) character- ized most American jackets. Helen Dryden noted in her article in *Advertising Arts* that "simple and usually abstract arrangements" made it possible to enliven even the most potentially dreary subject by giving the impression "that the text will be lively and interesting." George Salter concurred in his essay for the catalog of the Book Jacket Designers Guild that although "the ambassadorial power of the book jacket can be used constructively in building up confidence of the buying public the quality of a book jacket does not necessarily depend on the quality of the book." In this spirit a publisher of the day is reported to have said "give me a beautiful jacket on a book with blank pages and I'll sell it."

The character of a publishing house was often expressed through the styles of its jacket artists. Designers were usually selected either by the produc- tion manager, who directed the overall traffic of a publishing house from drawing board to printing press, or the editor, who on occasion in concert with the author, exercised artistic control. Few, if any, art or design directors were employed in those days, and so consistency was not an important concern. George Salter explained that "in choosing the designer for an assignment the [one who commissions it] consciously defines the basic style for the jacket. He may want to give the artist a free hand in which case he will equip him with a minimum of technical data . . . or may have a definite plan." Ben Feder, a former book jacket designer who worked for many of the major houses

during the 1940s and '50s, recalled in an interview that "the designers rarely read the manuscripts but rather were privy to the same short synopsis given to the salesmen. The resulting sketch or comp was then returned to the editor who probably showed it around the office for comment." Sales representatives had little say about design except where it could be quantified that a particular jacket either hindered or stimulated sales, and even then they might only have influence over details like the dominant color scheme as opposed to the basic jacket concept.

Jacket designers were mostly freelance and often worked for more than one publisher at a time. They were also usually generalists, skilled at illustration, hand lettering, and design. Yet it was not inconceivable that a jacket might be designed by two people, much like most advertisements. George Salter wrote that "as it is possible to use an old print or a photograph for a certain function in a jacket, it must also be possible to combine the work of two artists in one jacket. Both, drawing and lettering, are a means to an end: the jacket Above all the jacket must be *de- signed*, and if that cannot always be done by one and the same person it should, at any rate, be done by a *designer*, whether he is the painter or the letterer." This cautionary coda was in response to the houses where production personnel composed jackets without the benefit of a trained designer. The exem- plary designers were those who consistently created strong though economically rendered images that seamlessly integrated their lettering. Merely to leave space for lettering, as was the hallmark of an unde- signed jacket, within or around an image "ends in inorganic work," states Salter. "Such a jacket is painted but not designed."

A jacket must quickly evoke the aura of the book as it brands its title on the mind's eye. While not all jackets accomplished this, the goal itself was clear. So in the field of commercial art, creating an eye-catching, indeed memorable, book jacket was among the most challenging problems. "For in a space that on the average is little more than six inches by eight inches it has been necessary to convey visually, by word or design, the feeling and character of a book which often may run into four or five hundred pages," wrote Charles Rosner in *The Growth of the Book Jacket* (Harvard, 1954), a handbook on form and style. "Those who succeed in achieving this aim by the skillful use of one of the many media open to them, be it pictorial or typographical, have every right to be called true artists; and it is not unreasonable to speak of the *art* of the book jacket."

Yet even by the late 1940s jacket design was still practiced by a small tight-knit group. "There were probably no more than thirty artists working on a regular basis," recalls Ben Feder, who in 1947 was one of the founding members of the Book Jacket Designers Guild. He suggests that the main reason was financial: "Book jackets paid nothing—$75 average, $150 tops—so you had to make an awful lot of them to earn a living." But Feder admits that "the money may have been bad, but the artist was given a lot of freedom." And he is correct to the extent that jackets were not excessively scrutinized or altered by salesmen. But even George Salter admitted that these freedoms had practical limits. "In preparing his design the artist should bear in mind that the buying public does not know the content of a book beforehand, and that it is his primary obligation to interpret the substance of his book effectively." Freedom was also proscribed by the

prevailing trends and fashions. Although innovation was tolerated, it was not always encouraged when sales were in the balance.

During the three decades covered by *Jackets Required* the American bookjacket evolved rather quickly. Stylized ornament, realistic rendering, airbrushed figurations, hand lettering, and calligraphy went in and out of fashion frequently. Distinctive methods came and went as design waves crested and fell. Prolific book jacket artists of the '20s and '30s— among them Irving Politzer, Paul Wenck, Frank Macintosh, and Eugene "Gene" Thurston who adopted the most elegant American *art moderne* illustrative styles—had all but vanished by the late 1940s. Taking their place were modernist typographers like Alvin Lustig and calligraphers like George Salter (who was a highly respected innovator in his native Germany before emigrating to the United States in 1934). In the post-war period jacket design veered towards calligraphy and all-type covers in a conscious rejection of what Ben Feder refers to as "illustration *not* design." Objecting to the crass and tawdry art of the paperback and best-seller hardcover and decisively influenced by the European-inspired New Typography, young book jacket designers began to eschew overly decorative approaches through their own interpretations of Bauhausian typography. In *The Growth of the Book Jacket* Charles Rosner tells neophyte designers that "the pictorial is not the only means of expressing the poetic or dramatic character of a book. An equally effective medium is written or drawn characteristic lettering." By "characteristic" he was referring to a new calligraphic approach that was not as ornate, yet often much less exuberant, than the vintage '20s and '30s *art moderne* methods.

16

Calligraphy, like hand lettering, was governed as much by fashion as function. Since book jackets were usually tightly budgeted, typesetting was an added expense that often came out of the designer's own pocket. Though time-consuming, it was cheaper to create the display lettering by hand. But by the late 1940s typesetting became both cost-effective and a symbol of modern design. Ben Feder notes that typography in the modern tradition was even beginning to overtake calligraphy as the dominant form. Modernists Alvin Lustig and Paul Rand were on the cutting edge with jackets that combined abstract art and photography with modern typographic material. They created imagery that rejected fashionable conceits for a certain timeless purity. The new methods not only expressed a book's content but established a special relationship with the reader. "Abstract art, as a *tour de force* of mental concentration and a projection both of gist and spirit of a book," wrote Charles Rossner, "can establish the most immediate contact between intelligent book-buyers and intelligent writing."

Yet despite the best efforts of the Moderns to push the form beyond its conventions, book jacket design of the 1950s did not have considerable luster. Like the social and political temperament of America, the period's graphic style was comparatively conservative. Book jacket illustration, like its counterpart in the national magazines, was overly narrative, romantic, sentimental, and saccharine. Paperbacks were gaining in popularity and their covers, even for the classics, were quite crass. Likewise, publishers began to believe that some hardcover jackets, especially the potential best-sellers, should also have hard-sell (or not-much-left-to-the-imagination) graphics. This compelled publishers to distinguish their serious fiction and nonfiction by designing bewilderingly low-key "literary" wrappers—noted for being type heavy with minimal illustration. By comparison, the jackets from the '20s and '30s, which were deemed passé by the new generation of designers, art directors, and publishers, were decidedly more exciting, enticing, and fun to look at.

In the 1960s book jacket design regained stature as an innovative graphic design medium, equal to posters and record albums. Trade and quality paperbacks also emerged as wellsprings of fine contemporary graphics. By the mid 1980s jackets and paperback covers reached a creative zenith, suggesting a new golden age. And yet the currently high level of design aesthetics and sophistication, which has run the gauntlet of marketing mavens and demographic experts, when compared to many of those from the 1920s, '30s, and '40s, is somehow too slick—perhaps too professional. The best vintage work reprised in *Jackets Required* reveals a surprising lack of pretension. Although not to be confused with art for art (nor design for design), they reveal the struggle of how art and design were reconciled with commerce, and how literature was reconciled with mass culture. As such, they are masterpieces of interpretative packaging.

17

When introduced in the 1830s dust jackets were intended to keep books clean. The bookstore clerk removed the wrapper and handed an immaculate cloth copy to the customer. By the 1920s, particularly in cities where grime and soot prevailed, the dust jacket continued to serve its original function. By then, however, jackets were printed with such tantalizing images that discarding one was like vandalizing a piece of art. "The customer is demanding that the dust jacket should be as immaculate as the book," an anonymous author wrote in *75 Years or The Joys And Sorrows of Publishing and Selling Books at Duttons from 1852–1927,* "so that actually some books were manufactured . . . with a transparent glassine outer cover in order to protect the colored 'dust' cover."

Fiction jackets were more sumptuous than any other. "[T]he competition is fierce, for they must attract and direct innumerable passersby who are undecided, looking for books for entertainment or escapist enjoyment: here the cover can tip the balance and draw the much-wanted interest," wrote Charles Rosner in *The Growth of the Book Jacket.* The ability to visualize ideas and characters born of imagination was both a challenge and a necessity. The title and author's name was usually an inadequate

enticement for a potential reader. So graphics that signaled the essence, if not the plot, of a book became the prime inducement for the literary browser. Once piqued the reader was then treated to other bits of vital information on the front, back, and inside the jacket—a short synopsis, author's biography, and of course the ever-present blurbs.

When the illustrated jacket came into its own in the 1920s, marketing did not influence its art and design. While jackets for fiction were meant to attract attention, the manner had not yet been proscribed as would later be the case in the mass market paperback field or with hardcover best-sellers. Although within specific genres, such as mystery, thriller, and romance, conventions developed and duplication was unavoidable, there was nevertheless a wide stylistic range and many conceptual variations. Book jacket designers were compelled to understand the trends in bookstore window display. And as George Salter cautioned, "a great number of jackets, too similar in style, will cancel each other out."

Designing for fiction was relatively easy. In the absence of fact the artist required, and was allowed, considerable license. Yet the simplification endemic to jacket art could also result in clichés. Distilling the essence of a

novel was accomplished through either metaphor or literalism. But during the '20s and '30s Modernistic and Neo-Classical styles conveyed a sense of contemporaneity that was applied to virtually all books regardless of where they were set or in what period they were situated. Few attempts were made to re-create an accurate period style. The most interesting graphics were created with contemporary lettering and imagery adhering to a Modernistic poster aesthetic. By the end of World War II, when modern European typography was introduced to America, and photomontage and collage were making painted and drawn illustration passé, designers of fiction were even less inclined to mimic historical motifs which they looked upon as too quaint.

The '20s and '30s fiction jackets enjoyed Jazz Age exuberance—they were distinctly of their time. By the late '30s and '40s a modern ethos characterized by simplicity, austerity, and abstraction inspired by the European avant-garde had informed book jacket design. The symbolism was more abstract, the imagery more illusive than the earlier Modernistic approaches, and represented the art of *its* time. Regardless of style, during these three decades fiction wrappers led the way and set the standard of book jacket design.

ANIMAL FARM

Harcourt, Brace and Company Inc., 1946

Designer: Art Brenner

The abstract pattern does little to reveal the book's chilling metaphor.

POWER

Grosset & Dunlap, 1929

Designer unknown

In Germany this novel became the basis for the infamous, anti-Semitic film, "Jude Süss," the tale of an 18th-century Jewish power broker. Here, overlooking a symbolic chessboard, the Jew is holding his pouch of gold.

ALL QUIET ON THE WESTERN FRONT

Little, Brown & Company, 1929

Designer: Paul Wenck

Wenck's sympathetic sketch of the German soldier puts the human face on war.

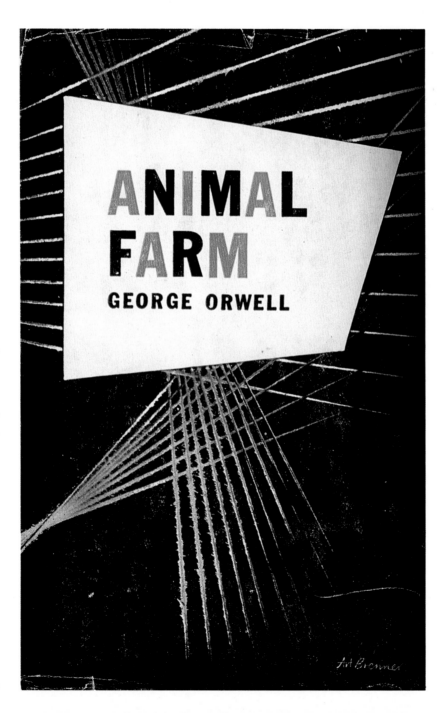

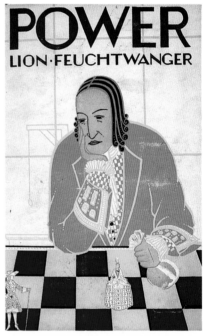

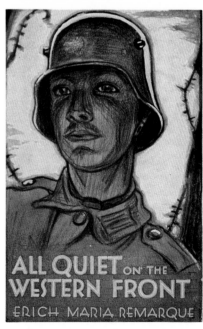

20

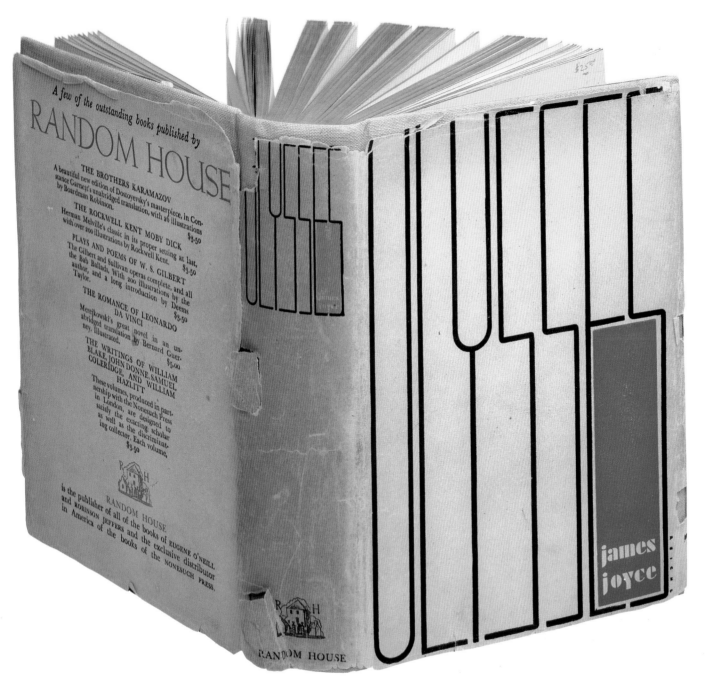

ULYSSES

(left)

Random House, 1934

Designer: Ernst Reichl

(below top)

Random House, 1947

Designer: E. McKnight Kauffer

(below bottom)

The Modern Library, 1946

Designer unknown

Each iteration of this modern classic rejects a typical narrative image in favor of a typography. But it is Kauffer's version that has become well-known.

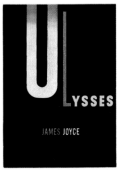

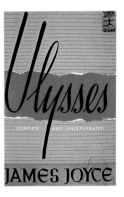

CANDIDE

Halcyon House, 1937

Illustrator: Rockwell Kent

Designer: Lucian Bernhard

This edition was packaged in a special slipcase printed with Kent's art and Bernhard's typography.

THE MAGIC MOUNTAIN

Alfred A. Knopf, 1927

Designer unknown

This slipcase served to jacket the two volumes of this important German book.

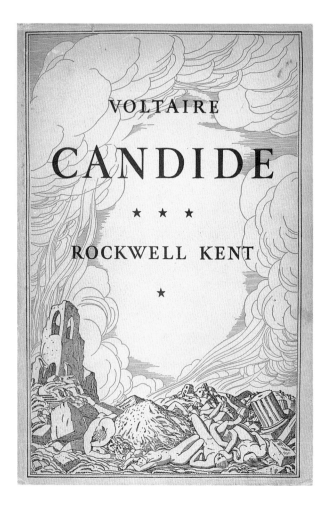

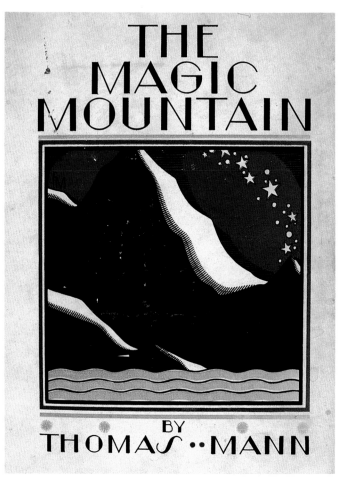

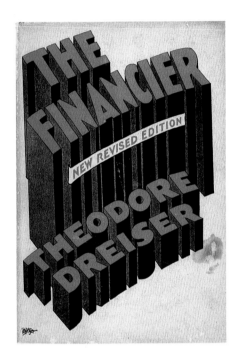

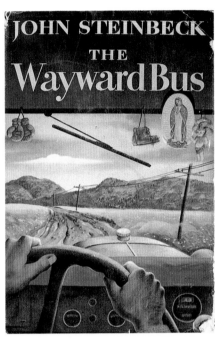

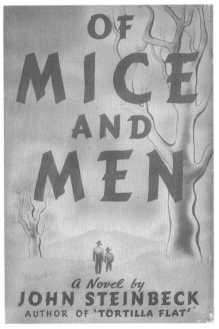

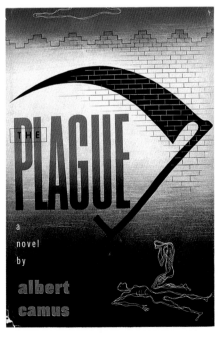

THE FINANCIER

Boni & Liveright, 1927

Designer unknown

Published in 1912, a dissatisfied Theodore Dreiser was compelled to rewrite it. The shadowed lettering reveals little about what was regarded as his greatest book.

THE WAYWARD BUS

The Viking Press, 1947

Designer: Robert Hallock

The perspective from inside the cab of the wayward bus brilliantly sets the stage for Steinbeck's novel.

OF MICE AND MEN

Covici-Friede Publishers, 1937

Designer: George Salter

Salter's airbrushed rendering of Steinbeck's "vagabonds and human flotsam" never quite meshed with the heavy brushstroke lettering.

PLAGUE

Alfred A. Knopf, 1948

Designer: Jean Carlu

The jacket for Camus' existential masterpiece is layered with symbolism of death and despair.

LOOKING BACKWARD

Houghton Mifflin Company, 1926

Designer: Roland Cosimini

Originally published in 1887, this look backward from the future was a masterpiece of prescience. This *art moderne* vision of the future projects an oppressive dystopia.

The Modern Library, 1949

Designer: E. McKnight Kauffer

Kauffer's surrealist imagery is a much more poetic interterpretation than the first version.

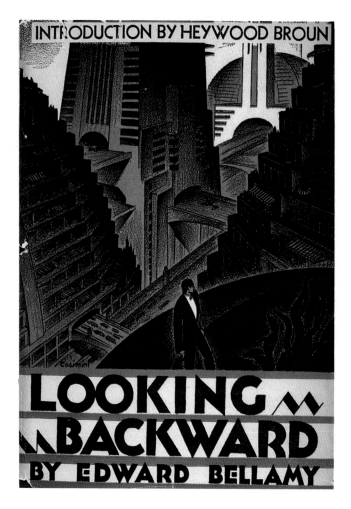

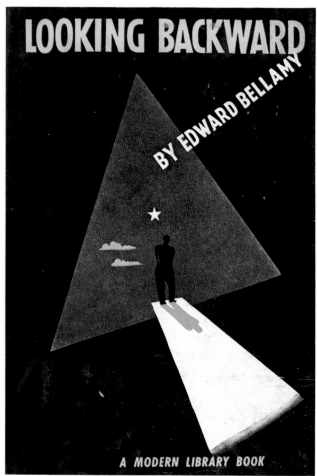

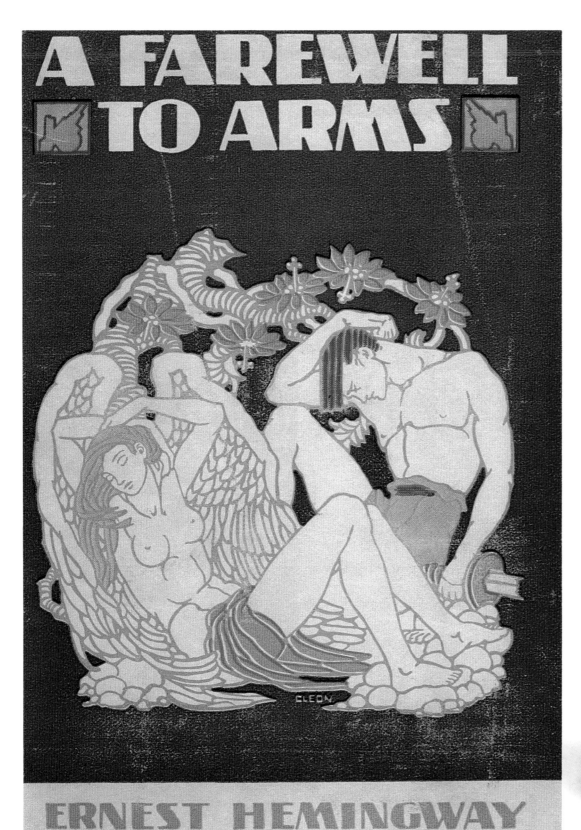

A FAREWELL TO ARMS

Charles Scribner's Sons, 1929

Designer: Cleon

This romantic but emotionless *art moderne* illustration ever so slightly expresses the plot of Hemingway's classic.

MOBY DICK

Bonibooks, 1935

Designer: Raymond Bishop

Melville's masterpiece has been dressed in various jackets. This example of *art moderne* is for an inexpensive reprint.

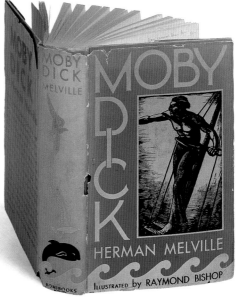

FICTION

DEEP EVENING

Jonathan Cape Harrison Smith, 1931

Designer unknown

For this tale about the voyage of an ocean liner the designer radically forces the perspective of this stylized vessel.

PYLON

Harrison Smith and Robert Haas Inc., 1935

Designer: Alfred Maurer

Nothing subtle about this jacket. The large slab serif type reminds one of posters for air carnivals, the setting of this book.

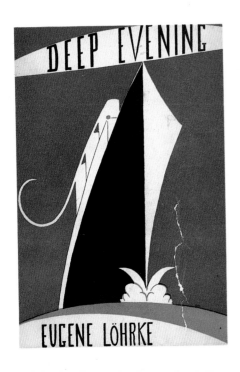

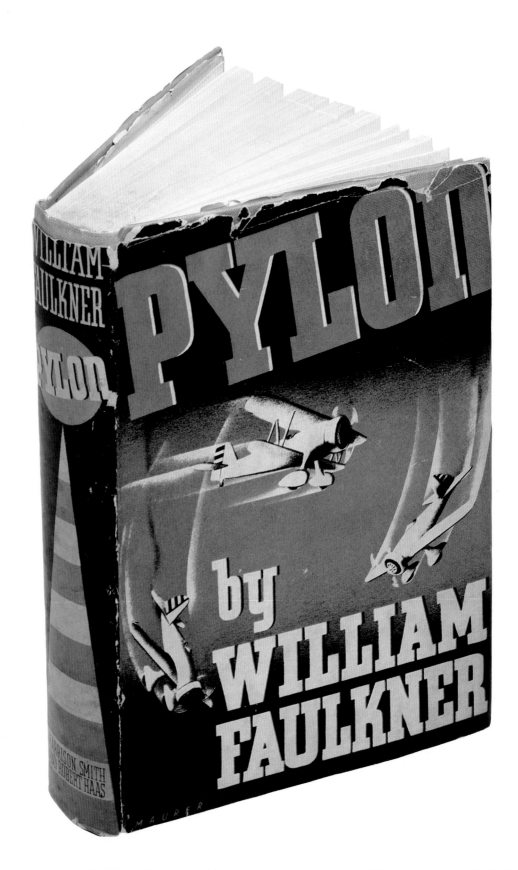

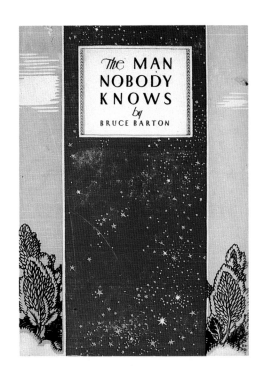

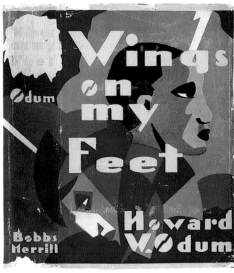

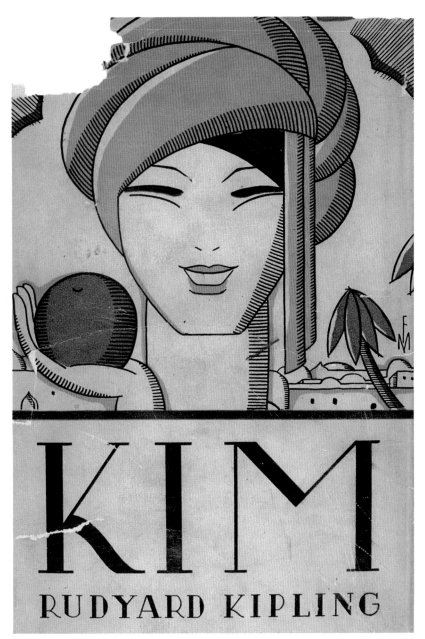

THE MAN NOBODY KNOWS

Grosset & Dunlap, 1925

Designer unknown

A subdued treatment introduces an "unconventional but wholly sincere and reverent book . . . a portrait of Jesus . . ." as a man "as real and alive as you and I."

WINGS ON MY FEET

Bobbs Merrill, 1929

Designer unknown

The kinetic style borrowed from Italian Futurism illustrates a novel about a negro soldier caught in the vortex of war.

KIM

Horace Liveright, 1929

Designer: Frank Macintosh

Macintosh provides a lovely *art moderne* interpretation of Kipling's 19th-century character.

LOVE IN MANHATTAN

Liveright Inc., 1932

Designer unknown

Illustrated in a period style, this raucous look at a New York cabaret was too good for just the front of the jacket.

THE LAST POST

Albert & Charles Boni, 1928

Designer unknown

Music notes scream across the sky in this beguilingly simple design.

FIFTH AVENUE BUS

Doubleday Doran, 1931

Designer unknown

A forced perspective of Fifth Avenue suggests the panoramic sweep of Morley's paeans.

A MAN COULD STAND UP

Grosset & Dunlap, 1926

Designer unknown

As the jacket image alludes: "Into this book is compressed a marvel-ously blended picture of the whole war."

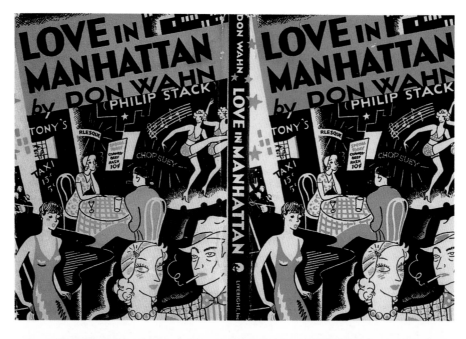

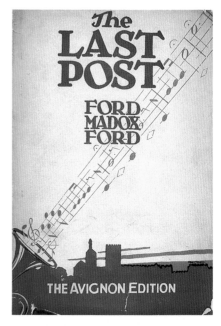

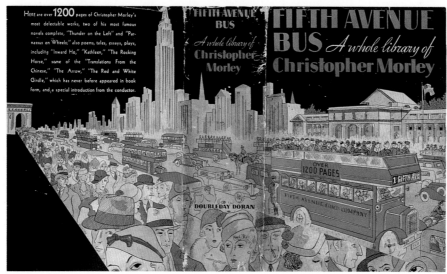

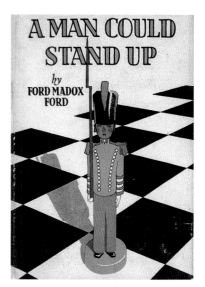

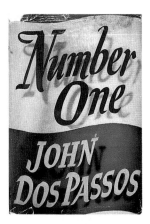

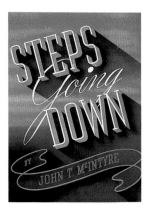

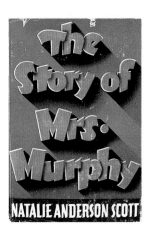

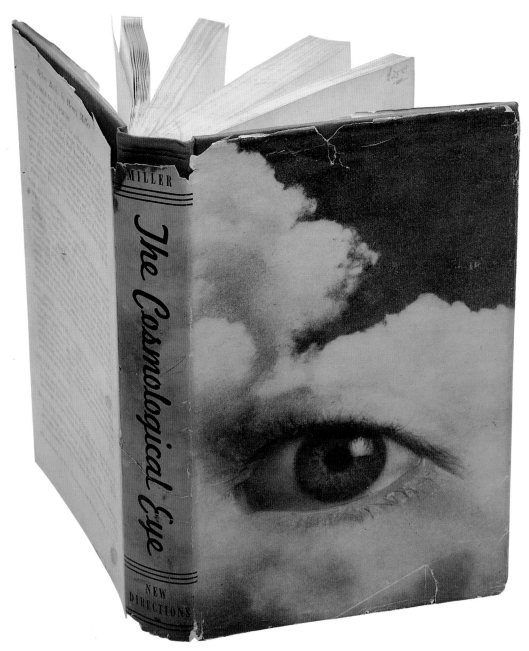

NUMBER ONE

Houghton Mifflin Company, 1941

Designer unknown

The dimensional lettering on this jacket may not reveal the plot of the novel, but it stood out on the shelves.

STEPS GOING DOWN

Farrar & Rinehart Inc., 1936

Designer unknown

With three colors and an array of shadows this jacket is reminiscent of contemporary movie titles.

THE STORY OF MRS. MURPHY

E.P. Dutton & Company, 1947

Designer unknown

Novelty lettering is inconsistent with the claim that "this is a novel that Dostoyevsky might have written if he were an American."

THE COSMOLOGICAL EYE

New Directions, 1939

Designer unknown

Leaving off the title and author from the front of the jacket was a radical, if dangerous, idea in 1939.

HANGOVER

Boni & Liveright, 1929

Designer unknown

A conventionally stylized rendition of the "dizzy denizens of the Gland Canyon known as Broadway."

SMART SETBACK

Alfred A. Knopf, 1930

Designer: Gorska

This epitome of *moderne* styling is apt for the "witty, sophisticated, and amusing story of New York's smart set."

HACKING NEW YORK

Charles Scribner's Sons, 1930

Designer unknown

The quintessential *moderne* cityscape sets the stage for the tale of a literary cab driver.

NINTH AVE

Boni & Liveright, 1926

Designer unknown

Using a street sign as the title of a book became a cliché, but it was still fresh in 1926.

BRINGING JAZZ

Horace Liveright, 1933

Designer unknown

Stenciled typography shoots off the cover as if from a jazzman's horn.

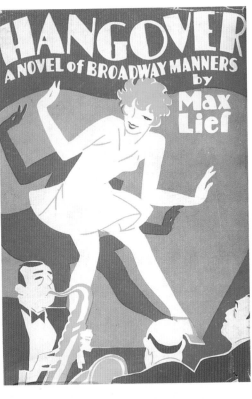

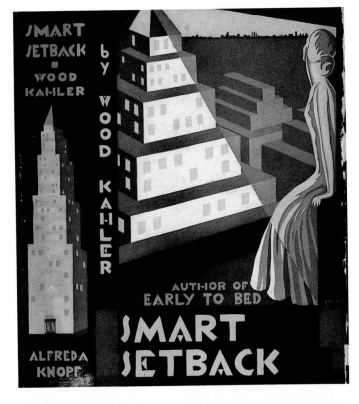

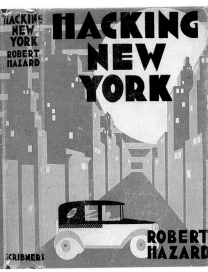

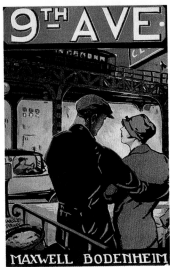

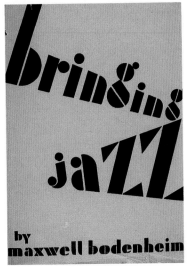

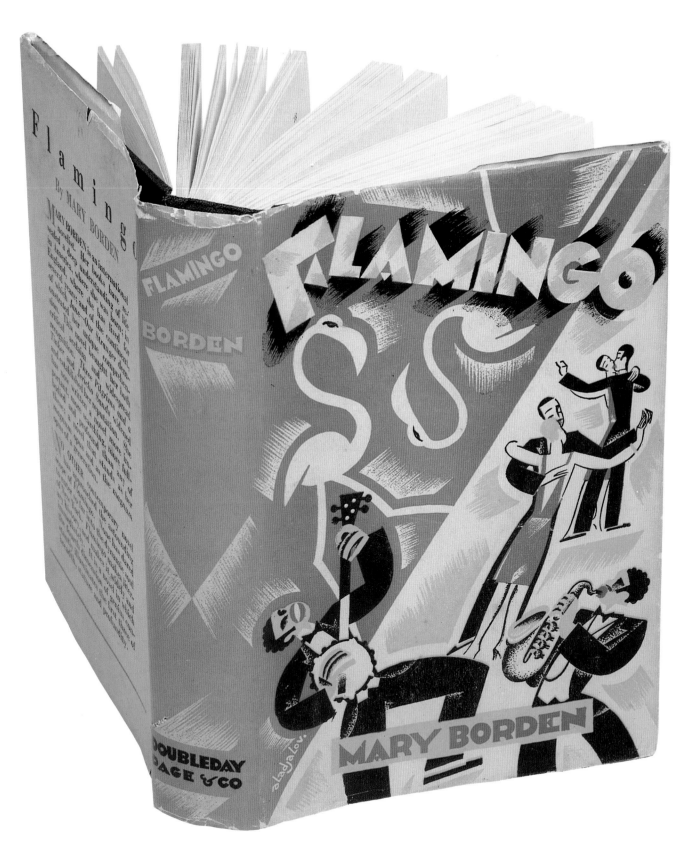

FLAMINGO

Doubleday, Page & Company, 1927

Designer: Aladjalov

The jacket for this novel about New York City nightlife is illustrated in the Jazz Age cartoon style of one of *The New Yorker's* leading cover artists.

BUTTERFIELD 8

(left)

*Harcourt, Brace &
Company, 1935*

Designer: Arthur Hawkins, Jr.

(top right)

*Harcourt, Brace &
Company, 1935*

Designer: Arthur Hawkins, Jr.

(bottom right)

Shakespeare House, 1949

Designer unknown

Hawkins's first comp
(left) evolved into the pub-
lished jacket (top right), a
clever use of lettering as
intersecting streets. The less
elaborate version is elegantly
simple; the addition of the
dash after the 8 in the title
refers to the way telephone
numbers were written then.

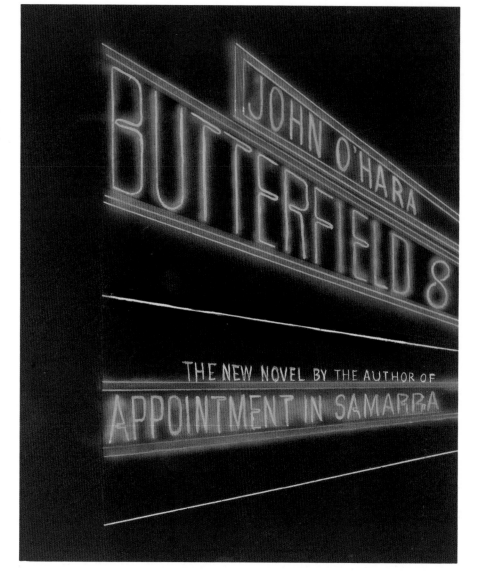

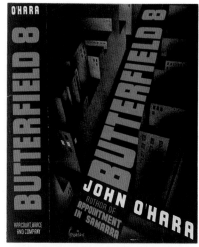

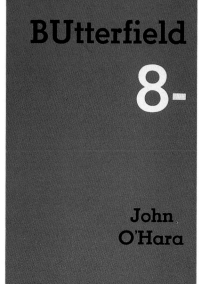

32

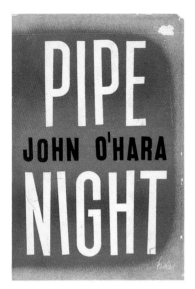

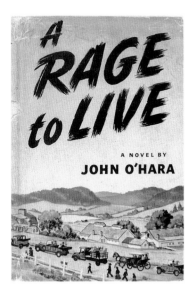

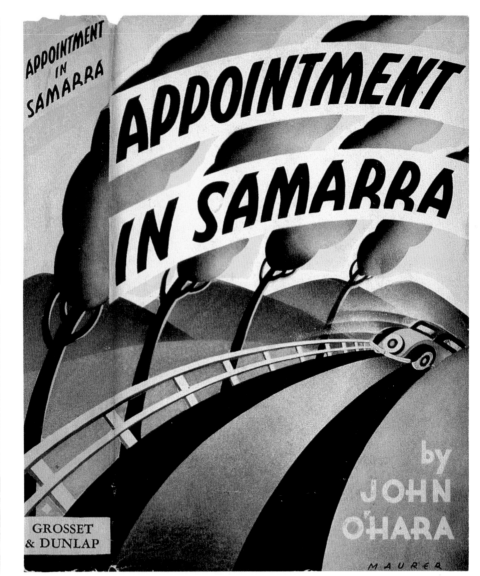

PIPE NIGHT

Duell, Sloan & Pearce, Inc., 1945

Designer: Arthur Hawkins, Jr.

It would be difficult to synthesize the plots of 31 stories in one illustration, hence the simple lettering solution.

A RAGE TO LIVE

Random House, 1949

Designer: John O'Hara Cosgrave II

Although the expressive lettering and the virtually comical painting do not sit harmoniously, the latter evokes the rage in the title.

APPOINTMENT IN SAMARRA

Grosset & Dunlap, 1934

Designer: Alfred Maurer

The title lettering suggests the speed of the motor car on its way to the fatal appointment.

GOD HAVE MERCY ON ME!

Macaulay Publishers, 1931

Designer unknown

A compelling image that aptly, if melodramatically, suggests the torment of this degraded lost soul.

THE LITTLE STOCKADE

E.P. Dutton & Co., Inc., 1939

Designer: L. Struker

The flap copy asks: "How does a woman become a prostitute? What is the bond between her and the pimp?" So why is this jacket illustration so . . . winsome?

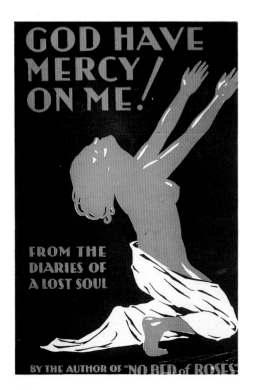

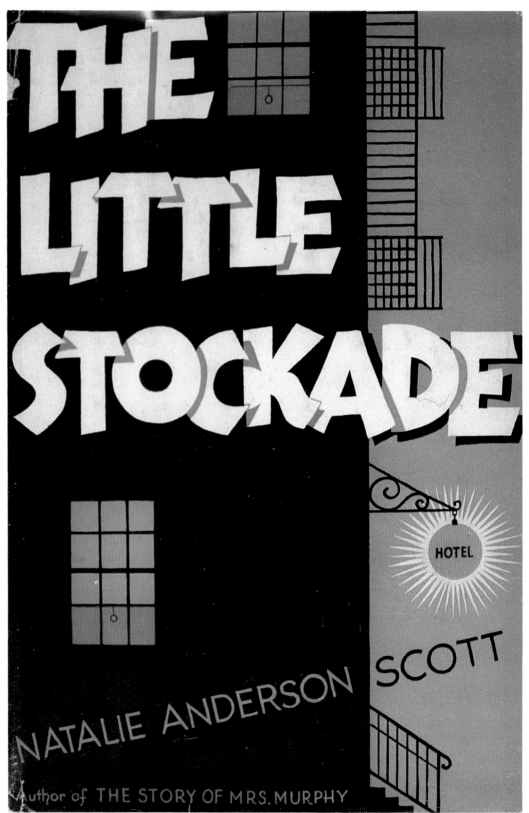

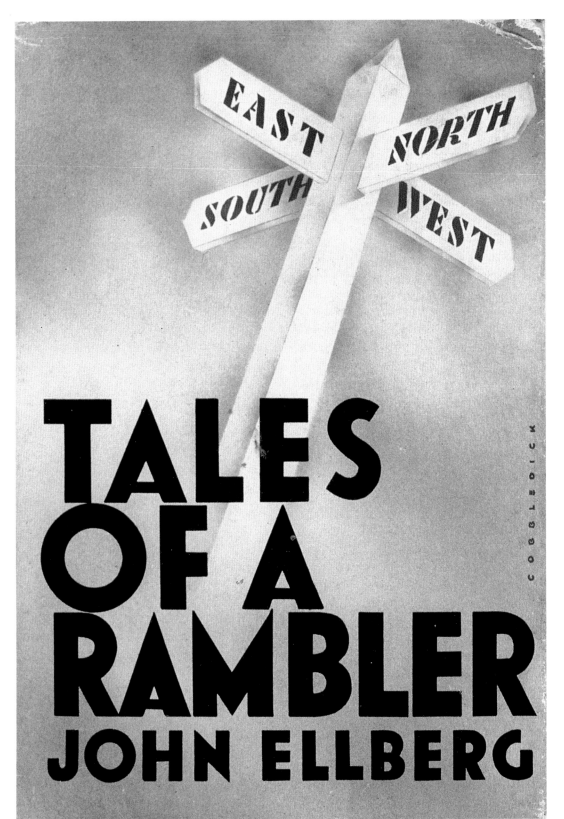

TALES OF A RAMBLER

*The Macauly Company,
1938*

Designer: Cobbledick

The bold gothic lettering is
set against an airbrushed
drawing of a directional
sign evoking the wander-
lust of this book.

WHISTLE STOP

Random House, c. 1946

Designer: H.J. Barsdell

Signs provide a convenient
vehicle for designers to
not only frame a title, but
suggest a plot.

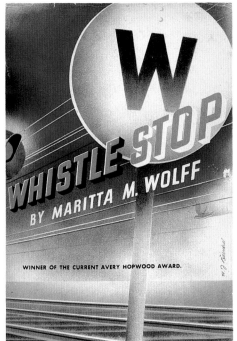

GREAT CIRCLE

*Charles Scribner's
Sons, 1933*

Designer: Cleon

BLUE VOYAGE

*Charles Scribner's
Sons, 1927*

Designer: Cleon

Both jackets are rendered
in a sensual *moderne* style
that provides little insight
into the plots of either book.

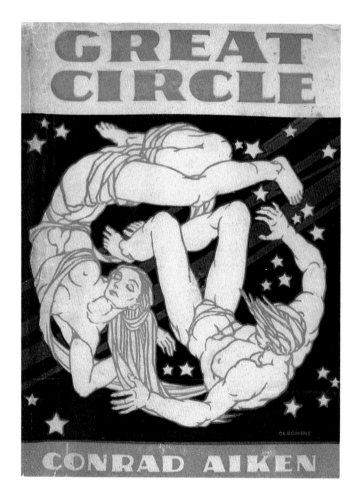

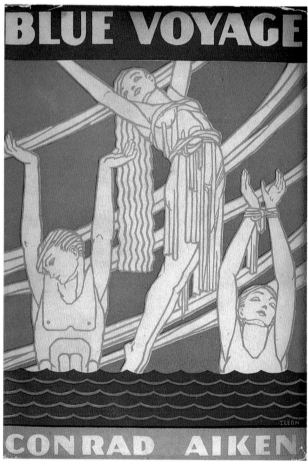

AS I LOOK AT LIFE

Publisher unknown, c. 1925

Designer: J. Nadejon

This surrealistic jacket is as mysterious as the book
itself. This proof is printed without flap copy or
publisher's imprint on the spine.

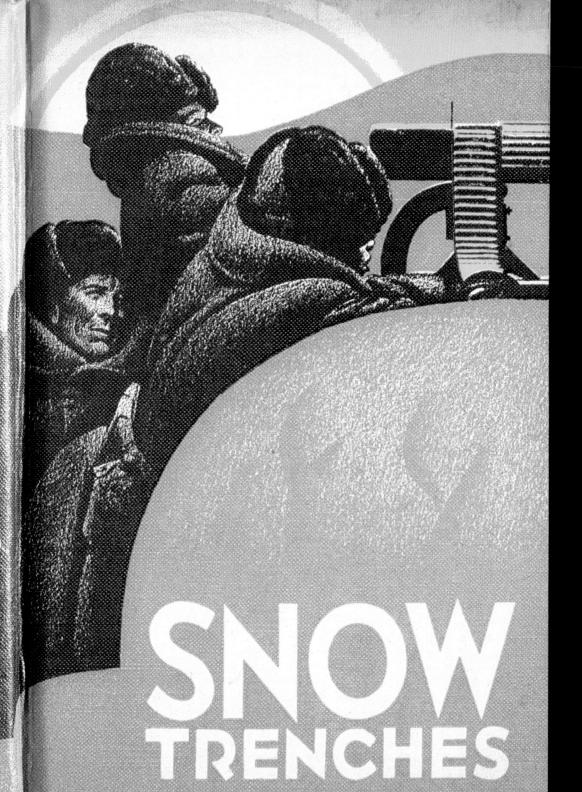

SNOW

TRENCHES

by DAN STEELE

SNOW TRENCHES
A.C. McClurg & Co., 193[?]
Designer unknown
This cover is a rare instance when the embossing was printed in color as it appears on the jacket.

CIMARRON

Grosset & Dunlap, 1930

Designer: Fredric C. Madan

In a style typical of western movie posters, a monumental hero towers over the lawless in Cimarron (illustrated with scenes from the Radio Picture starring Richard Dix).

THE MAN ON HORSEBACK

A.L. Burt Company, 1920

Designer: Burton Riley

How else does one illustrate a novel of "Ranch Life, Prospecting and Thrilling Adventures" set in Berlin and Coney Island?

WICKED WATER

Random House, 1948

Designer: E. McKnight Kauffer

Kauffer uses the signpost to introduce this western thriller, a mannerism that was all too common in book jacket design.

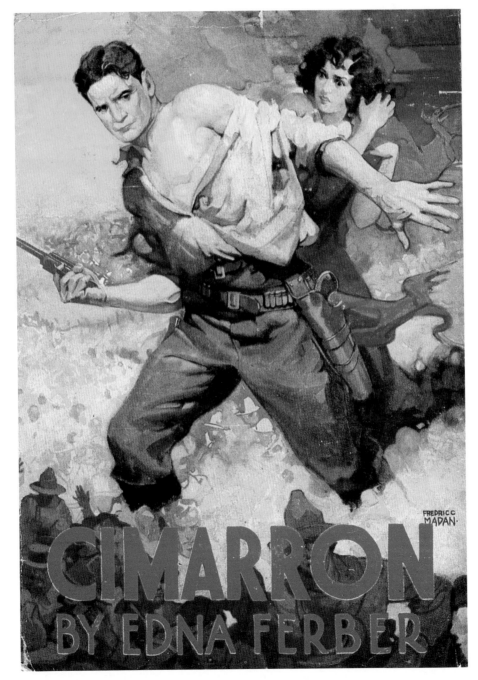

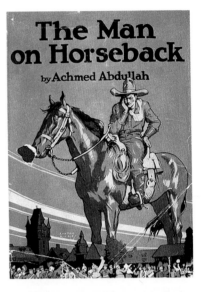

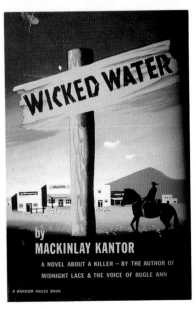

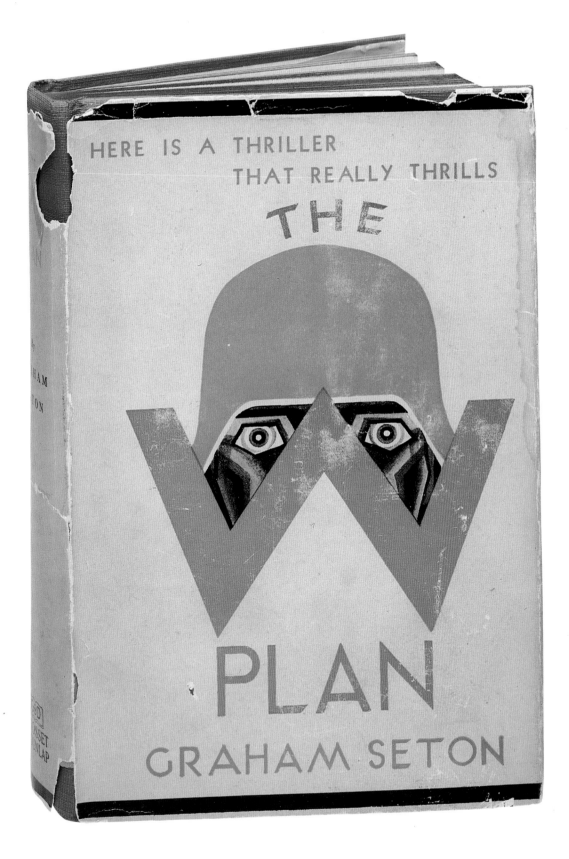

HERE IS A THRILLER
THAT REALLY THRILLS
THE
W
PLAN
GRAHAM SETON

THE W PLAN
Grosset & Dunlap, 1930
Designer unknown

For this World War I thriller
the W literally carves
through the expressionistic
face of a German soldier.

THE INVISIBLE HOST

The Mystery League, 1930

Designer: Eugene (Gene) Thurston

THE TINGAREE MURDERS

The Mystery League, 1931

Designer: Eugene (Gene) Thurston

THE DAY OF UNITING

The Mystery League, 1930

Designer: Eugene (Gene) Thurston

SPIDER HOUSE

The Mystery League, 1932

Designer: Eugene (Gene) Thurston

Mystery jacket designers usually took a melodramatic scene from the book, but jackets for The Mystery League set a new artistic standard. The principal artist, Eugene Thurston, developed a *noir* linear style which influenced the graphic presentation of mystery books, films, and television.

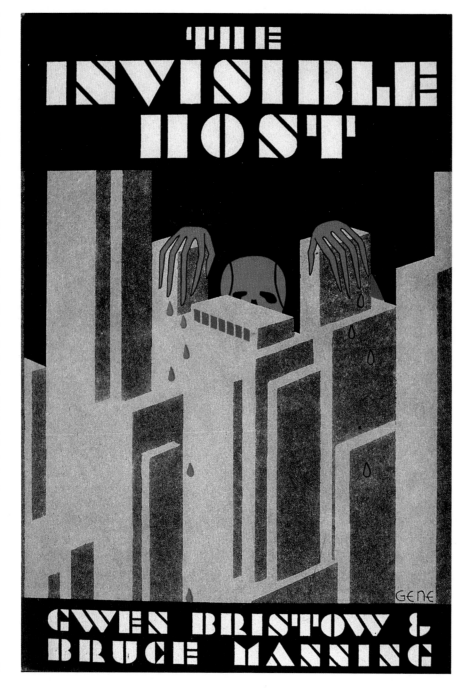

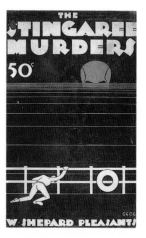

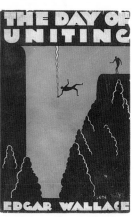

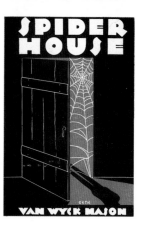

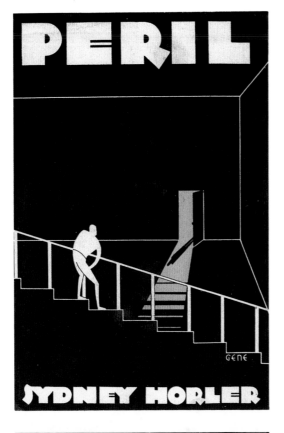

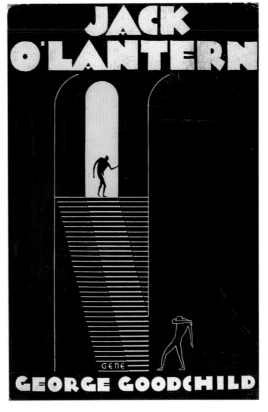

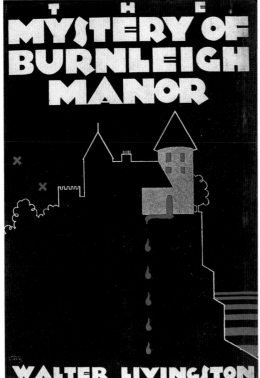

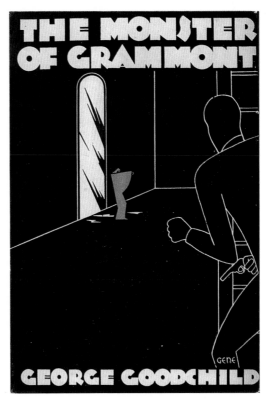

PERIL

The Mystery League, 1931

Designer: Eugene (Gene) Thurston

JACK O'LANTERN

The Mystery League, 1930

Designer: Eugene (Gene) Thurston

THE MYSTERY OF BURNLEIGH MANOR

The Mystery League, 1930

Designer: Arthur Hawkins, Jr.

THE MONSTER OF GRAMMONT

The Mystery League, 1931

Designer: Eugene (Gene) Thurston

MACHINERY

Horace Liveright, 1933

Designer: Jacks

Typical of the machine age, the gears of a motor are celebrated and romanticized for this mystery.

**THE CASE OF
SERGEANT GRISCHA**

The Viking Press, 1928

Designer: Paul Wenck

The jacket for this German novel about war avoids any literal interpretation of the plot in favor of an eye-catching color pattern.

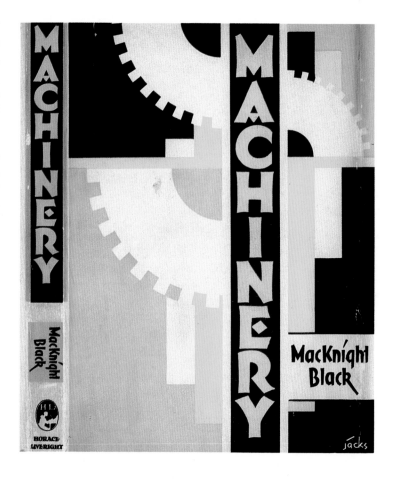

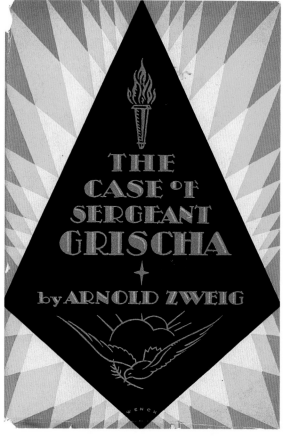

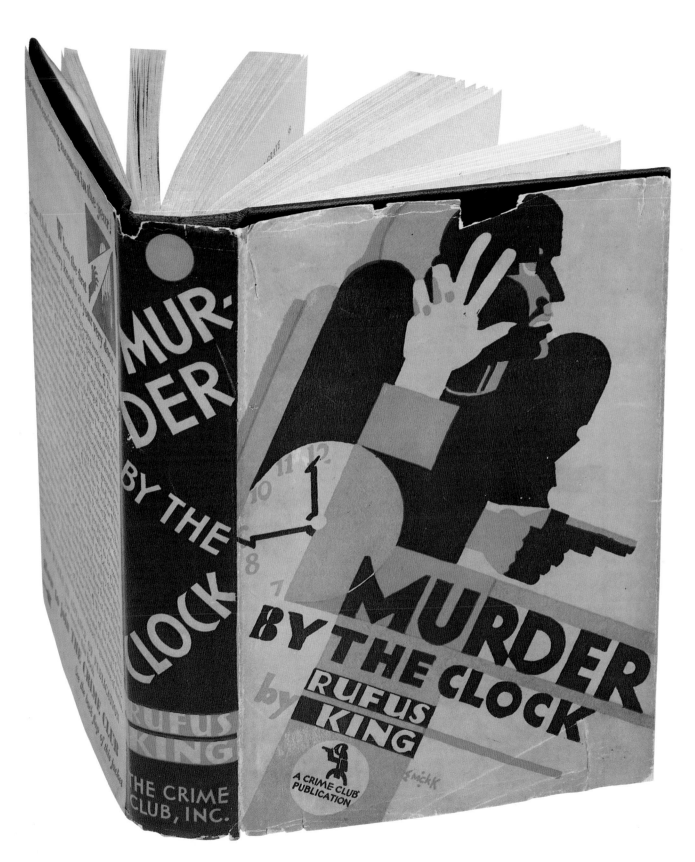

**MURDER BY
THE CLOCK**

*Doubleday, Doran &
Company, 1929*

Designer: E. McKnight Kauffer

This jacket by Kauffer for an
early Crime Club Publication
is dramatically rendered in
the Constructivist style.

MAN WITH FOUR LIVES

Farrar & Reinhart, 1934

Designer: Lynd Ward

The gaunt face on the jacket suggests that this suspense novel is "a story of horror."

THE DEVIL

Alfred A. Knopf, 1928

Designer unknown

The linocut of the devil aptly expresses this histori-cal suspense yarn, and yet the lettering is rather contemporary.

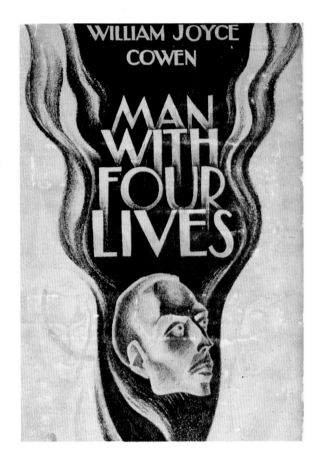

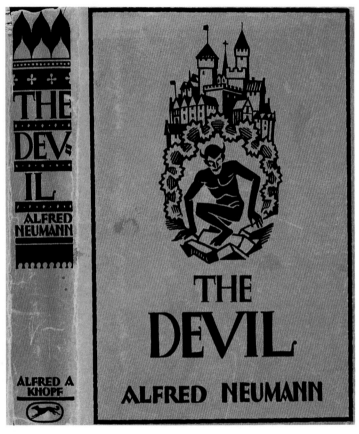

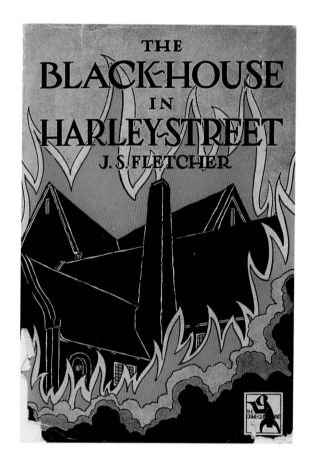

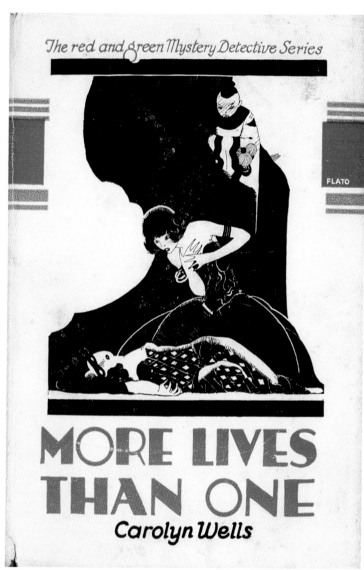

THE BLACK HOUSE IN HARLEY STREET

The Crime Club, 1928

Designer unknown

An evocative representation, this jacket illustration represents the novel's evil black house.

MORE LIVES THAN ONE

Boni & Liveright, 1923

Designer unknown

The stylized melodramatic nature for this "corking mystery" that introduces detective Lorrimer uses negative space to suggest danger.

THE LONE WOLF'S SON

J.B. Lippincott Company,
c. 1935

Designer: "ZAN"

The steamship's vent is the focal point of this poster-like image depicting intrigue on the ocean.

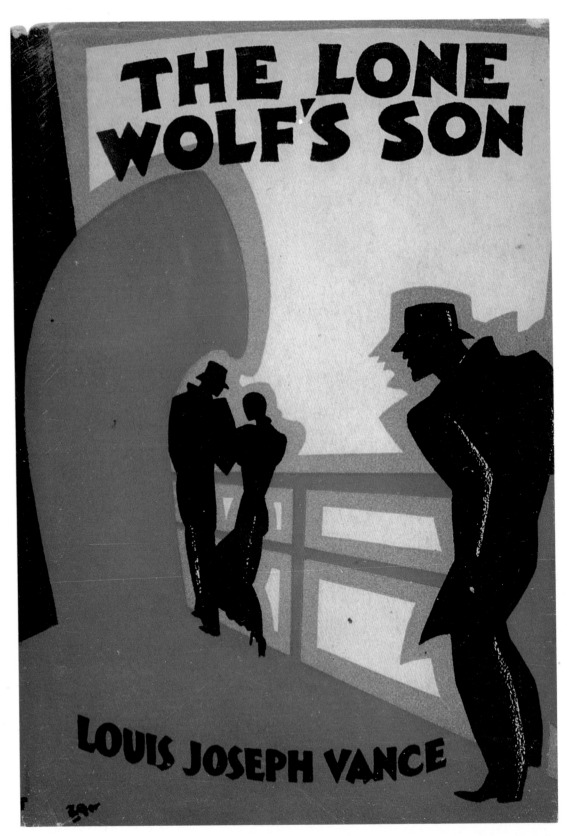

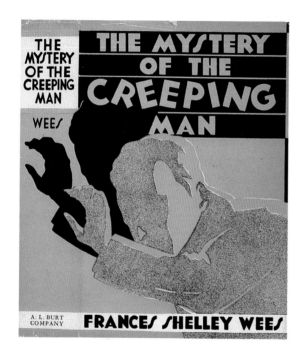

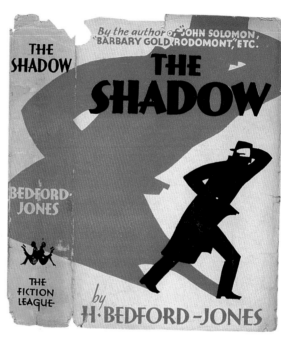

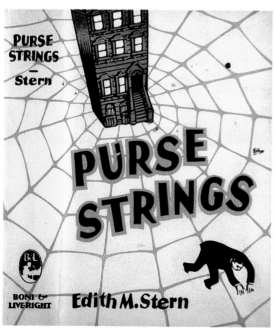

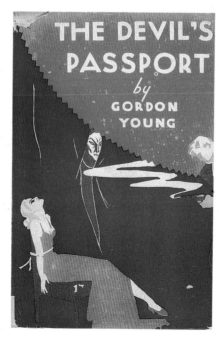

THE MYSTERY OF THE CREEPING MAN

A.L. Burt, 1931

Designer unknown

The shadow is an oft-used metaphor for mystery and suspense.

THE SHADOW

The Fiction League, 1930

Designer unknown

The shadow is a favorite *noir* cliché used aptly for this book of the same name.

PURSE STRINGS

Boni and Liveright, 1927

Designer unknown

The web seems to entangle the entire cover in this mysterious, yet comic, drawing.

THE DEVIL'S PASSPORT

A.L. Burt Company, 1933

Designer unknown

This vignette of murder includes many enticing images printed in an unusually bright combination of colors.

**THE TRAIL OF THE
BLACK KING**

Tudor Publishing, 1933

Designer: BB

The drawing evokes the
"unknown criminal that
stretches across London,
blighting the lives of every-
one it touches."

**THE CLUE OF THE
LEATHER NOOSE**

*Whitman Publishing Co.,
1929*

Designer: "G"

The rendering in a comic
book style with flat pulp
colors reveals the dime
novel flavor of this mystery.

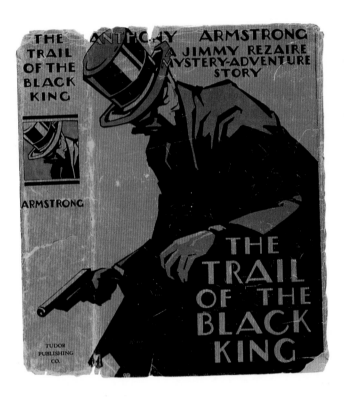

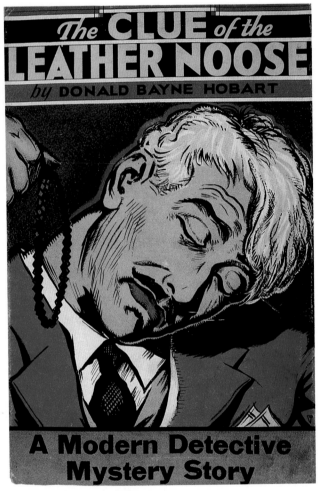

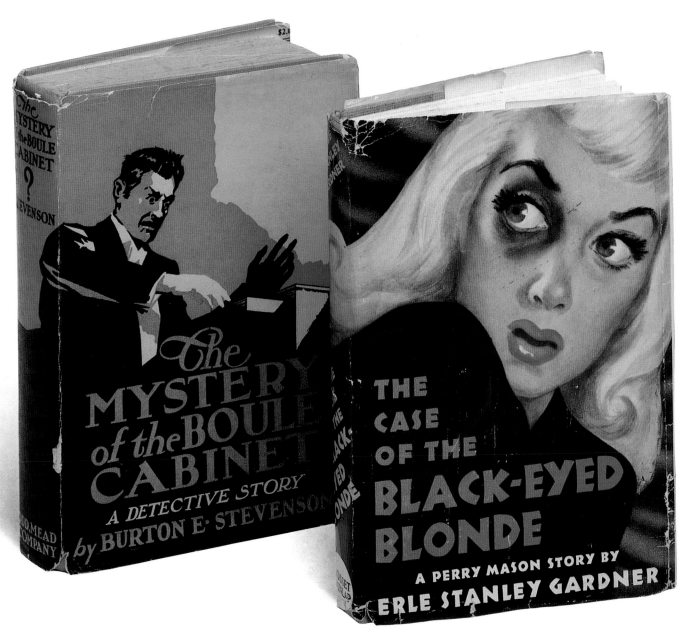

THE MYSTERY OF THE BOULE CABINET

Dodd, Mead and Company, 1929

Designer unknown

He looks like a magician, but it's really the protagonist searching for clues in the mystery cabinet.

THE CASE OF THE BLACK-EYED BLONDE

Grosset & Dunlap, 1944

Designer unknown

Illustrated with a sensational painting of a victimized woman, this jacket, like other Perry Mason classics, sells on sex appeal.

**THE CASE OF
THE VELVET CLAWS**

Grosset & Dunlap, 1933

Designer: Gorska

Like the shadow, the hand
—particularly a woman's
—became a cliché of
mystery jackets.

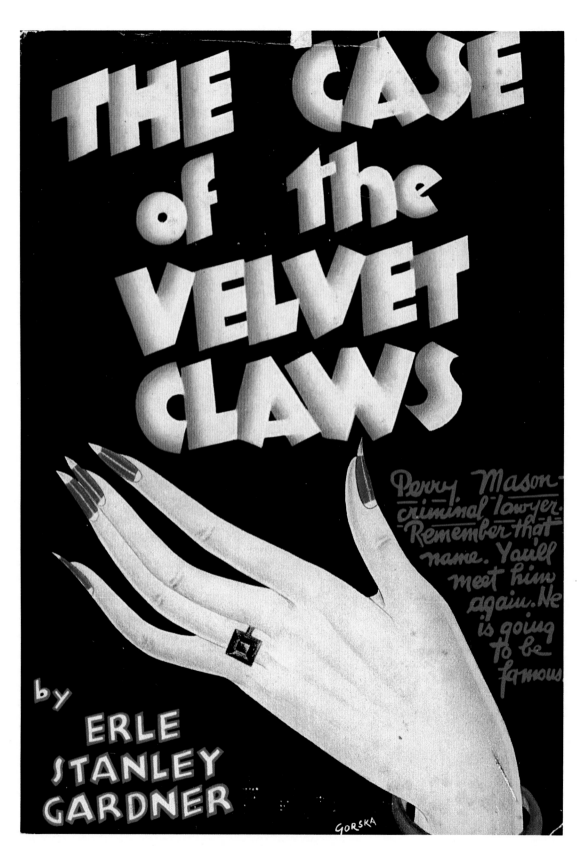

THE CASE of the VELVET CLAWS

Perry Mason—
criminal lawyer.
Remember that
name. You'll
meet him
again. He
is going
to be
famous

by ERLE STANLEY GARDNER

GORSKA

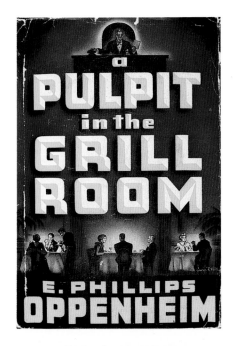

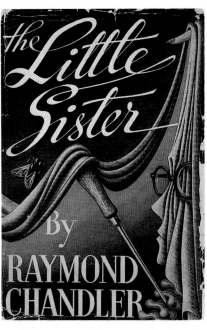

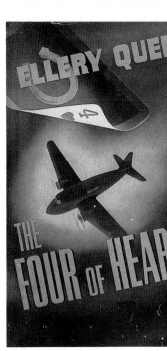

A PULPIT IN THE GRILL ROOM

Little, Brown and Company, 1939

Designer: George F. Kelley

Louis, *maitre d'hotel* of a London restaurant is crippled. The hotel owner built for him a small, low pulpit so he could see the suspense as it takes place.

THE LITTLE SISTER

Houghton Mifflin Company, 1949

Designer: Boris Artzybasheff

Philip Marlowe is not the centerpiece of this cover, but the clues to solving his case are.

THE QUARTZ EYE

Bobbs Merrill, 1928

Designer unknown

The eye in a camera lens was a surrealist conceit that literally illustrates this enigmatic title.

THE FOUR OF HEARTS

Triangle Books, c. 1948

Designer unknown

Triangle books were reprints of popular fiction priced affordably with jackets that prefigured the paperback.

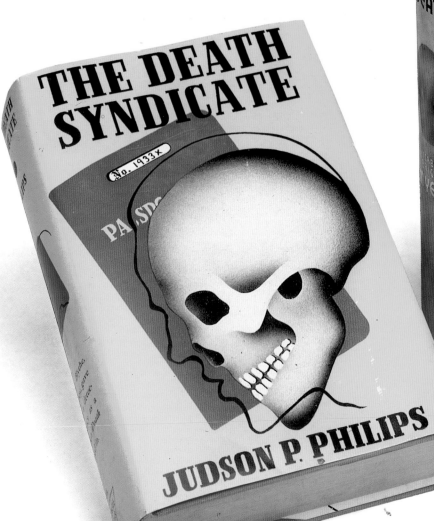

THE DEATH SYNDICATE

Triangle Books, 1938

Designer unknown

"Carole, Mark and the irrepressible Max find themselves entangled in a plot that is breath-taking for its speed, horror and aching suspense." The jacket is also generic.

54

GIVE ME DEATH

Blue Ribbon Books, Inc., 1934

Designer: Soch

This coarse airbrush rendering is nevertheless an eye-catching way to hook readers in this competitive genre.

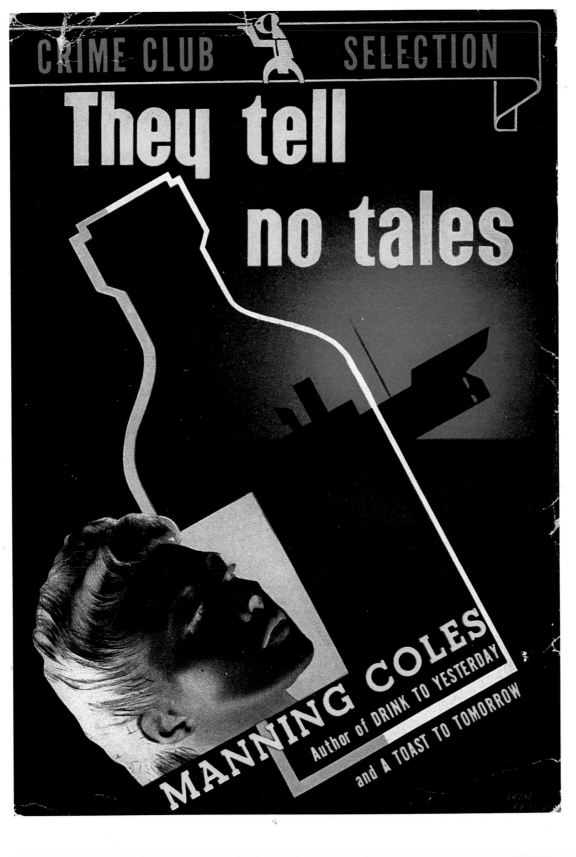

CRIME CLUB SELECTION

They tell
no tales

MANNING COLES
Author of DRINK TO YESTERDAY
and A TOAST TO TOMORROW

THEY TELL NO TALES
Book League, 1942
Designer: Jean Carlu
Carlu applies the Modern
approach in this collage of
painting and photography
on an asymmetrical axis.

CROOKED

A.L. Burt Company, 1927

Designer: A. H. Bolton

This *art moderne*-inspired perspective of skyscrapers evokes the big city life that comes shattering down on the novel's protagonist.

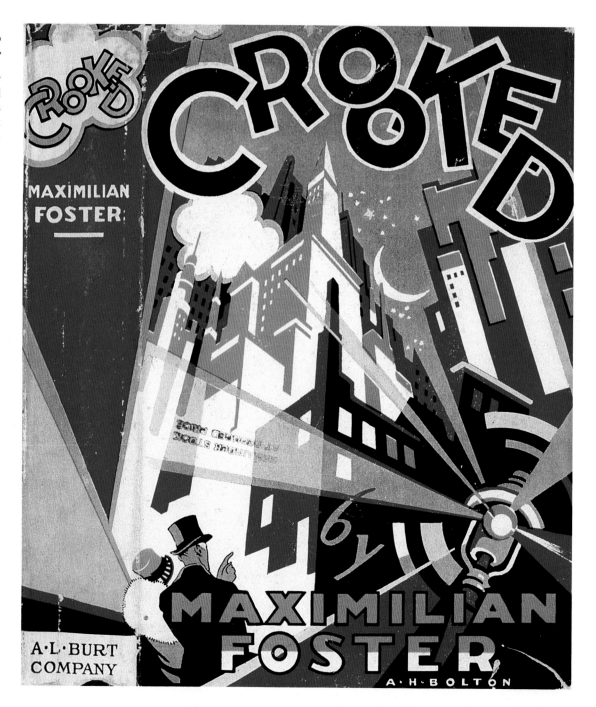

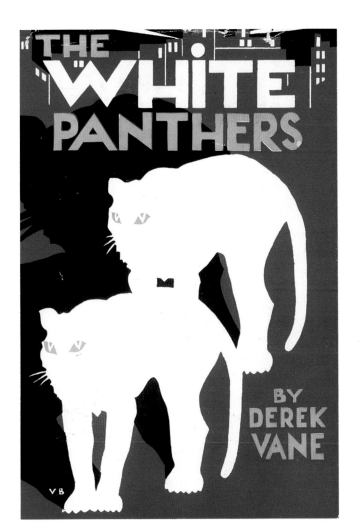

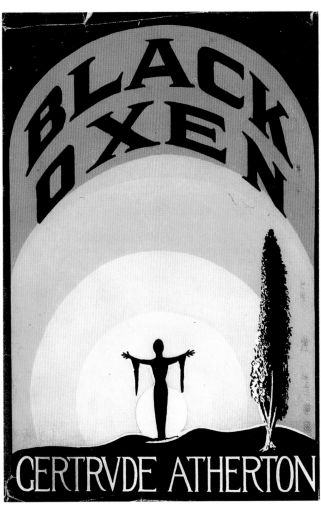

THE WHITE PANTHERS

Macmillan, 1930

Designer: "V.B."

The title refers to the name of a group of men who, on the seventh evening of every month, played a game of "danger, intrigue, and quick wits."

BLACK OXEN

Boni & Liveright, 1923

Designer unknown

This plot hinges on "beautiful, glorious Mary Zatianny," who explores "the deeper recesses of a woman's nature," and herself is personified in the jacket art.

HUMOR

THE CIRCUS OF DOCTOR LAO

The Viking Press, 1936

Designer: Boris Artzybasheff

"[This] is a strange book; no one will say what it means, or if it means anything at all; the author himself professes ignorance and washes his hands of the whole business. We publish the book because it made us laugh, and because a little hilarity is needed in the world."

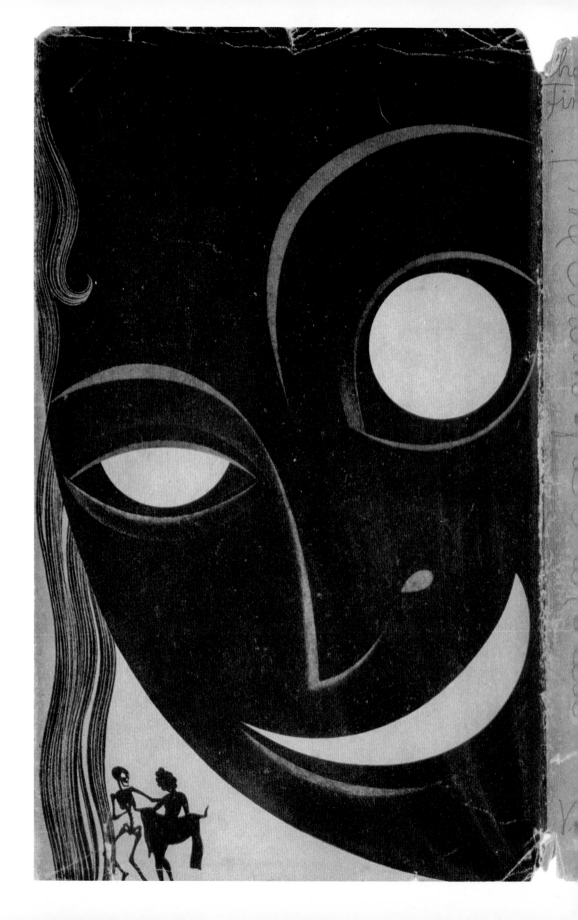

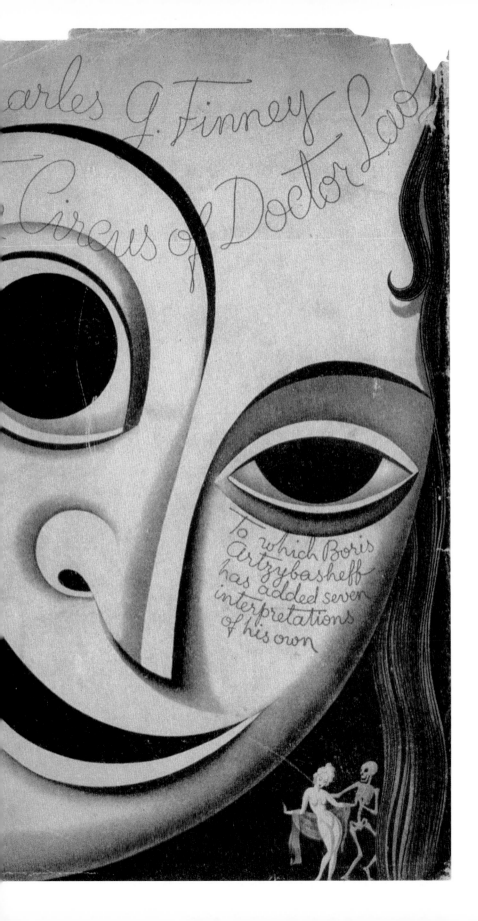

arles G. Finney

Circus of Doctor Lao

To which Boris
Artzybasheff
has added seven
interpretations
of his own

ARCHY & MEHITABEL

Doubleday, Doran and Company, 1928

Designer: "J.W."

Originally published with George Herriman's cartoons on the jacket and inside, this edition's jacket art is more stylized.

THE HAPPY ALIENIST

Harrison Smith and Robert Haas, Inc., 1936

Designer: Pierre Martinot

A pop surrealistic landscape is used to illustrate this "Viennese Caprice."

SHORT CIRCUITS

Dodd, Mead and Company, 1929

Designer unknown

This witty jacket speaks volumes about this short book that covers the foibles and follies of the present day.

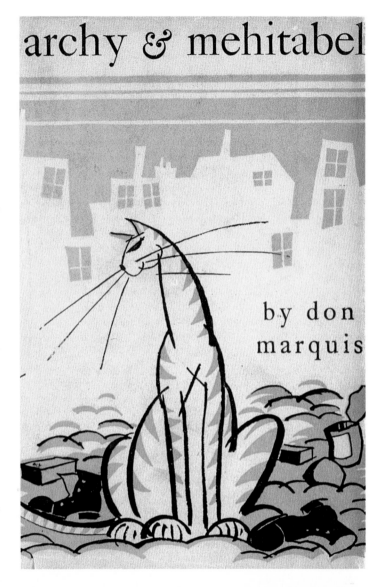

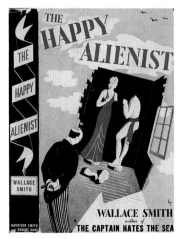

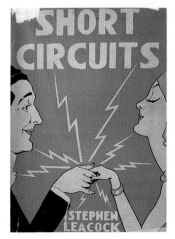

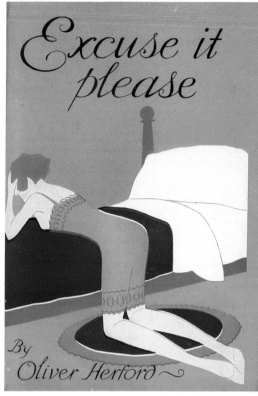

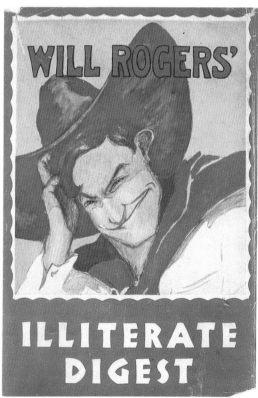

RUNYON A LA CARTE

J.B. Lippincott Company, 1944

Designer: Nicolas Bentley

Many cartoonists have illustrated Damon Runyon's urban vignettes; Bentley's are among the best.

EXCUSE IT PLEASE

J.B. Lippincott Company, 1929

Designer: Oliver Herford

A prolific cartoonist and humorist, Herford provides his own graphic interpretation for his book about a telephone operator.

THE MOTT FAMILY IN FRANCE

Little, Brown and Company, 1937

Designer: Hildegard Woodward

A humorous tale of an American family and their pratfalls in France, illustrated by the jacket artist.

WILL ROGERS' ILLITERATE DIGEST

Bonibooks, 1935

Designer: E. Auerbach Levy

Few faces were as famous as Will Rogers'. Few were better subjects for caricature, like the one on this jacket.

'R' YOU LISTENIN'?

Reilly & Lee, 1931

Designer unknown

TONY'S SCRAPBOOK

Reilly & Lee, 1932

Designer unknown

Tony Wons was a popular CBS radio personality whose annual script compilations were frequently jacketed in a festive *art moderne* style that evoked the carnival-like flavor of his shows.

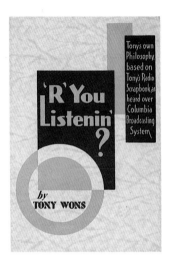

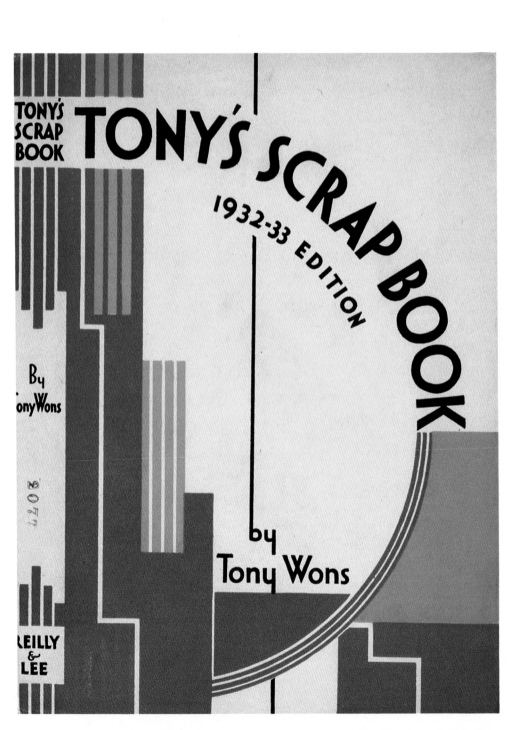

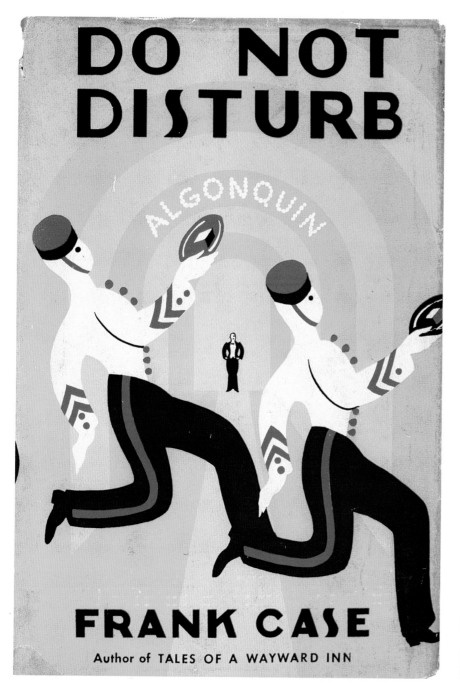

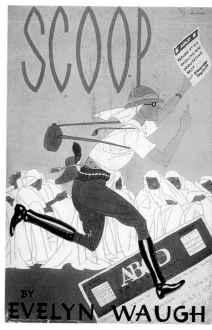

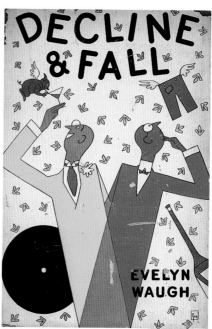

DO NOT DISTURB

Frederick A. Stokes Company, 1934

Designer unknown

These stories are from that hotbed of wit and urbanity, The Algonquin Hotel, which is symbolically represented here.

SCOOP

Little, Brown and Company, 1938

Designer: Harry Beckhoff

Evelyn Waugh's sophisticated satires always were adorned with comic images that reflected an *au courant* cartoon style.

DECLINE AND FALL

Farrar & Rinehart, Inc., 1932

Designer: Gardner Rea

Rea's idiosyncratic line was the epitome of Jazz Age acerbity and quite apt for Waugh's delightful tale of misadventure.

JUAN IN AMERICA
Farrar & Reinhart, 1933
Designer: Lee-Elliott
This pattern illustrates the
flap copy: a "gay and crazy
kaleidoscope of life."

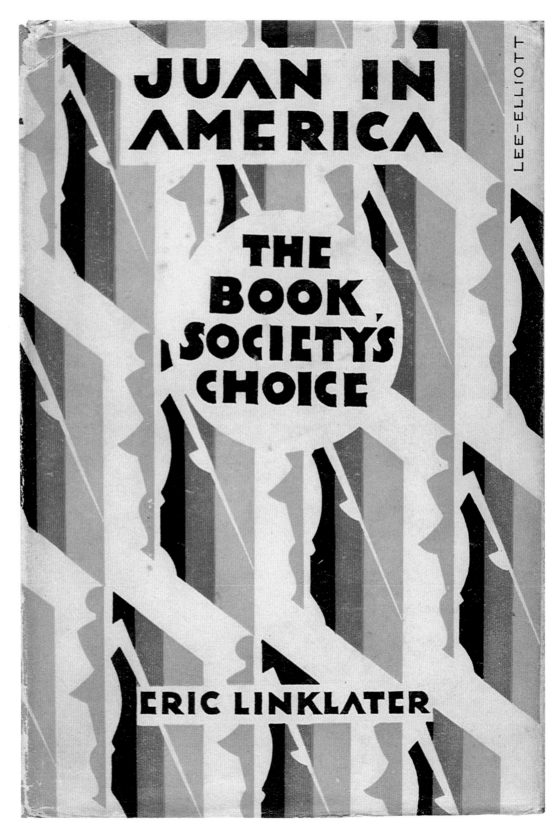

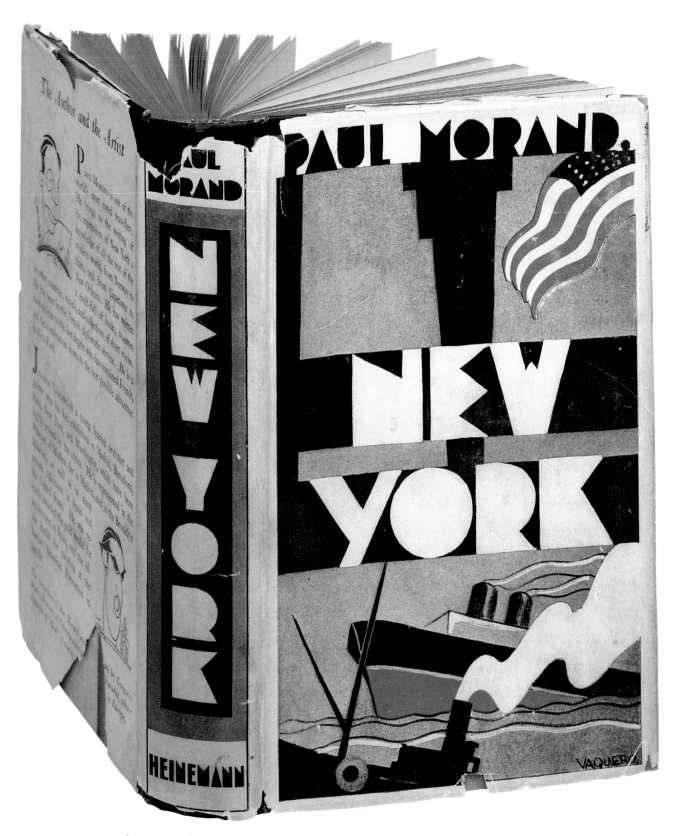

NEW YORK

*William Heinemann
Limited, 1931*

Designer: Joquin Vaquero

This contemporary jacket,
which originated on the
British edition, suggests a
European's first voyage
to America.

MOSTLY MISSISSIPPI

Dodd, Mead and Company,
1935

Designer: Harold Speakman

This semifictional account of a trip down the Mississippi was illustrated by its author.

CANNIBAL COUSINS

Minton, Balch & Co.,
c. 1943

Designer: Walter Cole

This is a personal tale of life in Haiti. Fact and fiction converge in this historical pastiche of the Caribbean island.

THE TIDES OF MALVERN

William Morrow &
Company, 1930

Designer: "M.F."

The story of an old Southern family whose barony is handsomely depicted outside of Charleston, South Carolina.

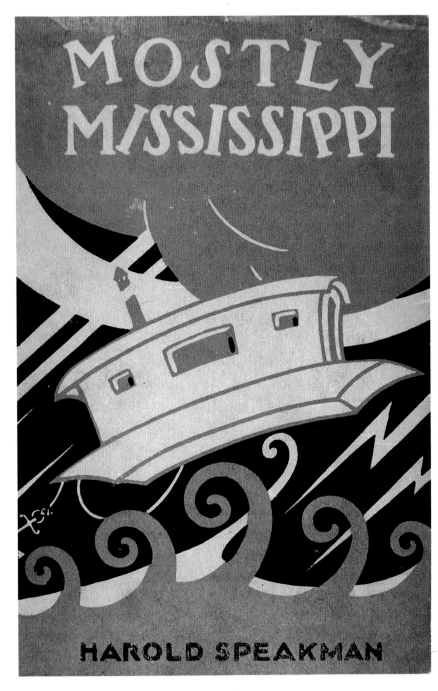

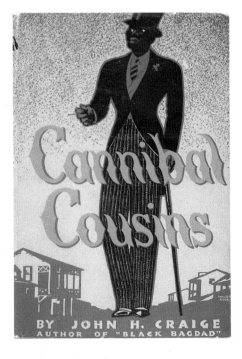

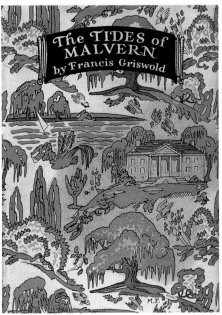

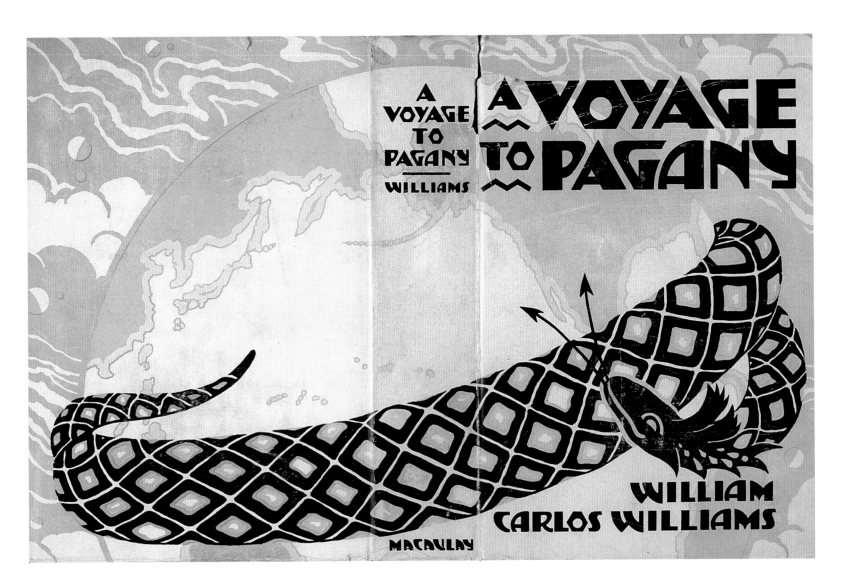

A VOYAGE TO PAGANY

Macmillan, 1934

Designer unknown

A sweeping image that covers front and
back jacket rendered in an uncommonly
eloquent manner.

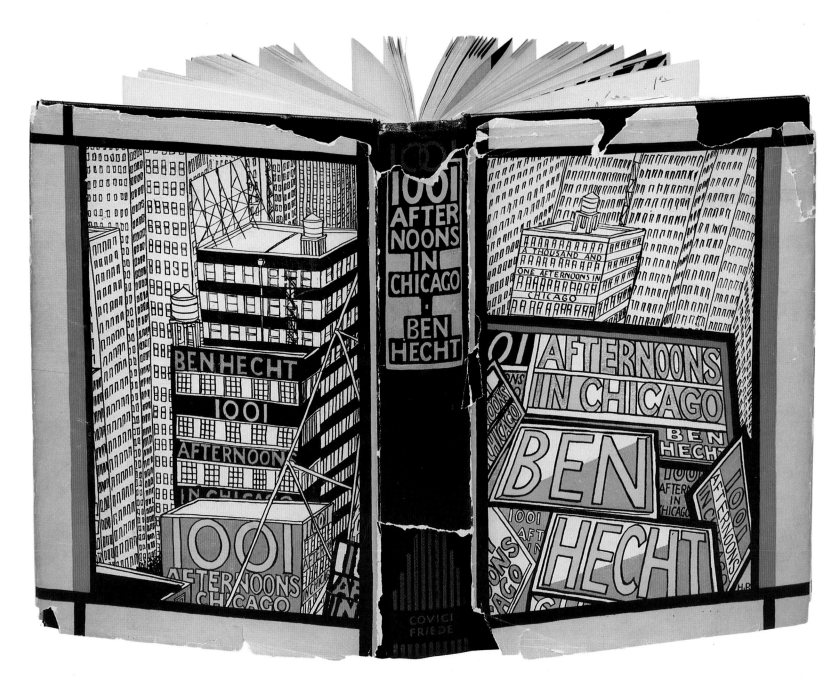

1001 AFTERNOONS IN CHICAGO

Covici Friede Publishers, 1934

Designer: Herman Rosse

Ben Hecht was known for his Chicago-based fiction. In this profusely illustrated book, rendered in the loose manner of the jacket, he rhapsodizes about his hometown.

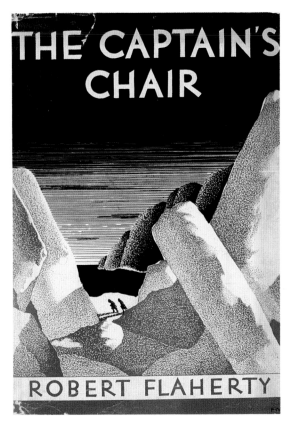

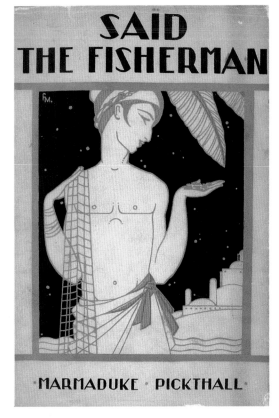

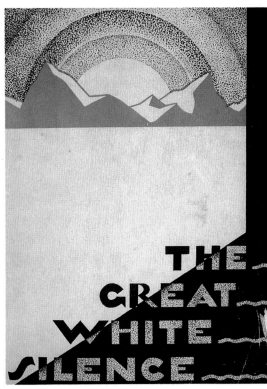

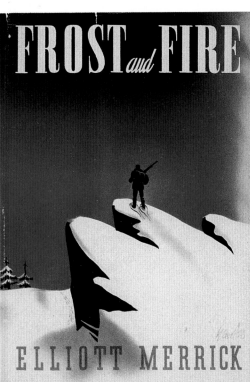

THE CAPTAIN'S CHAIR

Charles Scribner's Sons, 1934

Designer unknown

The stippled technique, printed in two colors, suggests the frigid climes of the North Pole.

SAID THE FISHERMAN

Alfred A. Knopf, 1933

Designer: Frank Macintosh

Known for his magazine covers, Macintosh elegantly depicts the young fisherman against an idealized Near East backdrop.

THE GREAT WHITE SILENCE

Charles Scribner's Sons, 1934

Designer unknown

The negative space below the horizon line simulates the frozen tundra.

FROST AND FIRE

Charles Scribner's Sons, 1945

Designer: Arthur Hawkins, Jr.

The tale about a subarctic trapper's struggle for existence vividly told in this simple image.

**THE WOMAN WHO
COMMANDED
500,000,000 MEN**

Horace Liveright, 1929

Designer: Paul Wenck

This enticing title is
equaled by the seductively
graphic portrait of the
Chinese dowager.

MILLIE

Triangle Books, 1930

Designer: Vineertini

Romantic realism accentu-
ates this sultry beauty.

RYDER

Horace Liveright, 1928

Designer: Sugar

Djuna Barnes often illus-
trated her own work, and
this jacket image by an
artist known as Sugar curi-
ously resembles her style.

GEORGIE MAY

Boni & Liveright, 1927

Designer: Irving Politzer

With few lines and a close
crop on the head, this face
evokes beauty and mystery.

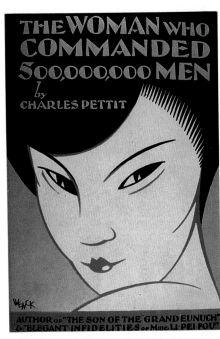

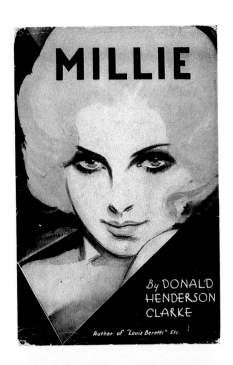

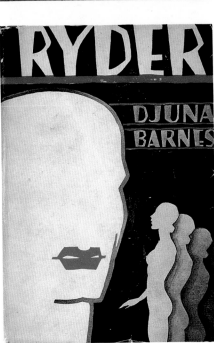

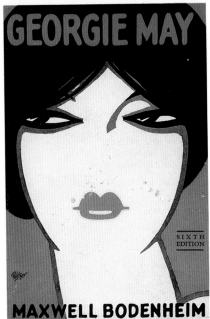

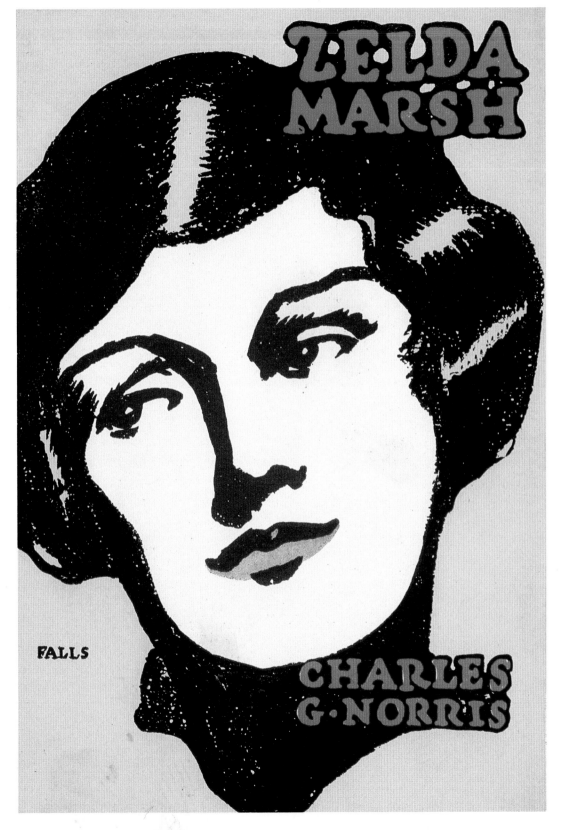

ZELDA MARSH
Grosset & Dunlap, 1925
Designer: A.B. Falls
Here a beautiful, if innocent, face draws the potential reader.

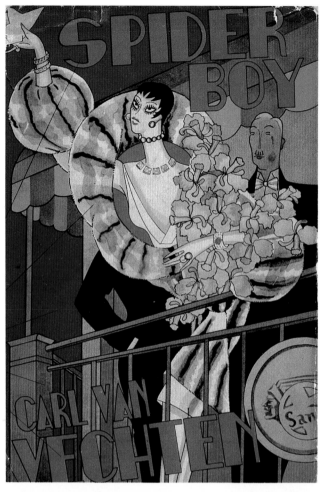

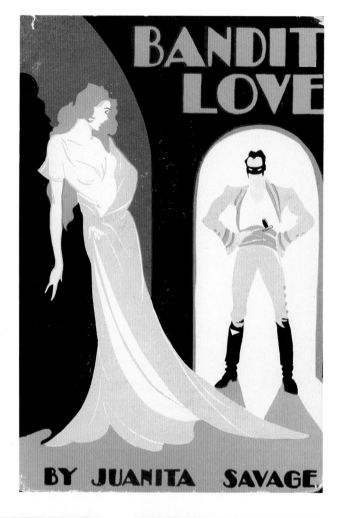

SPIDER BOY
Alfred A. Knopf, 1928
Designer: Ronald McRae

BANDIT LOVE
A.L. Burt Company, 1929
Designer unknown

MEN ARE SUCH FOOLS
Farrar, Rinehart, 1936
Designer: "R.B.C."

UNMARRIED COUPLE
Triangle Books, 1938
Designer unknown

AND MORE ALSO
G.P. Putnam's Sons, 1937
Designer unknown

From raucous *art moderne* to romantic realism, a couple shown in love (or near love) was a popular convention.

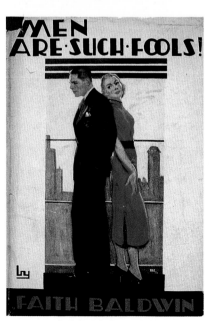

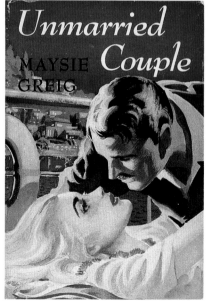

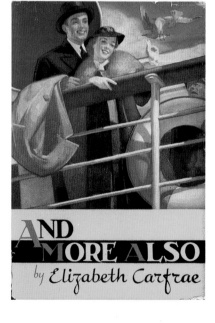

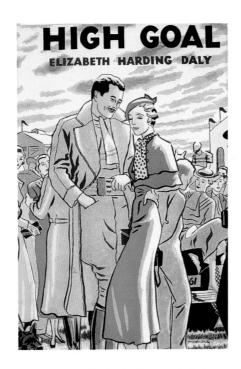

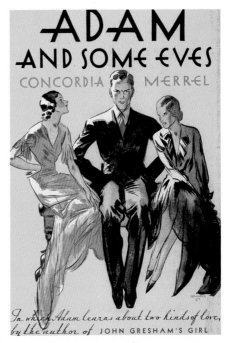

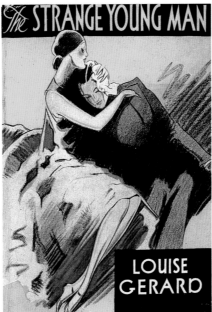

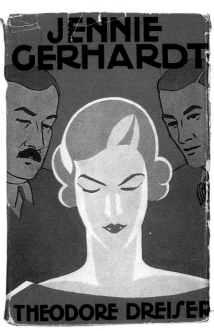

HIGH GOAL
Grossett & Dunlap, 1932
Designer unknown

ADAM AND SOME EVES
Grossett & Dunlap, 1934
Designer: Holmgren

**THE STRANGE
YOUNG MAN**
Macaulay Publishers, 1934
Designer unknown

JENNIE GERHARDT
Horace Liveright, 1926
Designer unknown

These commercial renditions of lovers and other strangers became the model that paperback covers would later follow.

CONSEQUENCES

Grosset & Dunlap, 1936

Designer: Peggy Morris

HIS OWN ROOFTREE

Grosset & Dunlap, 1933

Designer: Charles Horgans

COME OUT OF THE PANTRY

Dodd, Mead & Company, 1928

Designer unknown

SANINE

Illustrated Editions Company, 1932

Designer: Irving Politzer

HER PAUPER KNIGHT

A.L. Burt, 1929

Designer: Edward C. Caswell

SECOND CABIN

Horace Liveright Inc., 1937

Designer unknown

Commercial, but not tawdry, was how publishers marketed many of their love stories.

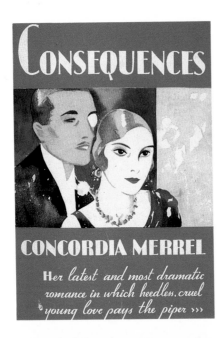

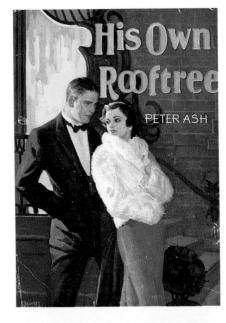

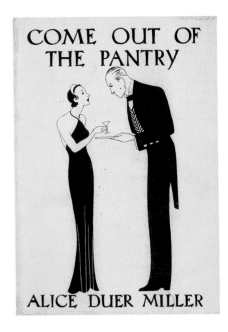

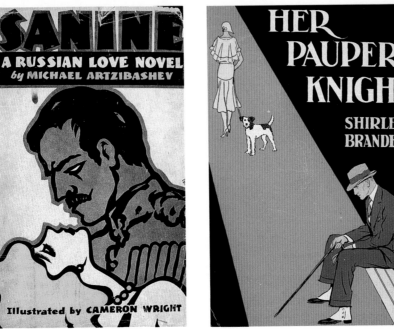

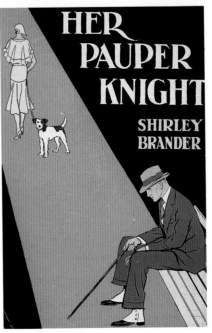

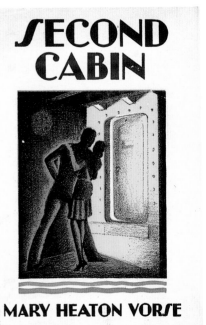

74

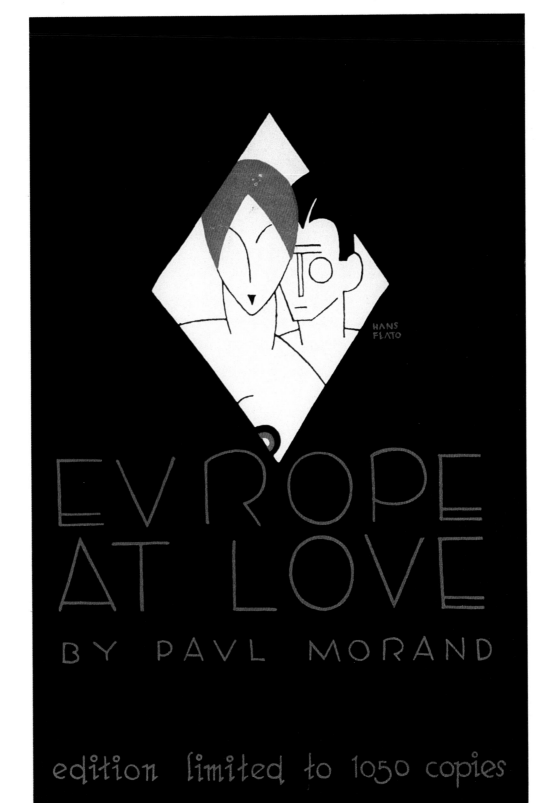

EUROPE AT LOVE

Bonibooks, 1932

Designer: Hans Flato

The jacket for Paul Morand's love story is rendered in the quintessential *moderne* style, with just a hint of lasciviousness.

GORGEOUS
Grosset & Dunlap, c. 1934
Designer unknown
A large letter frames the idealized portrait of a girl who was the most "widely photographed model of them all."

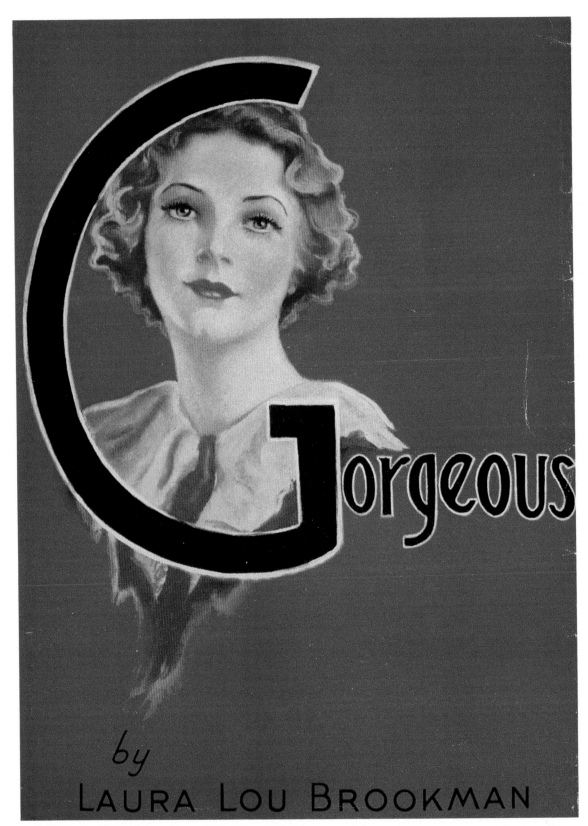

Gorgeous

by

LAURA LOU BROOKMAN

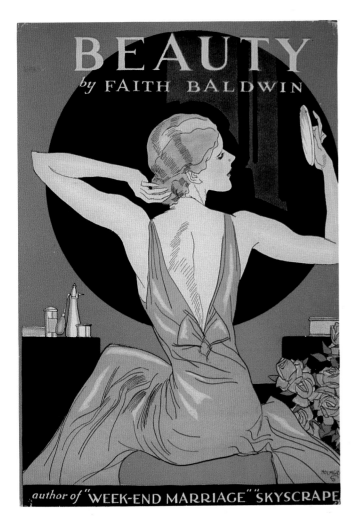

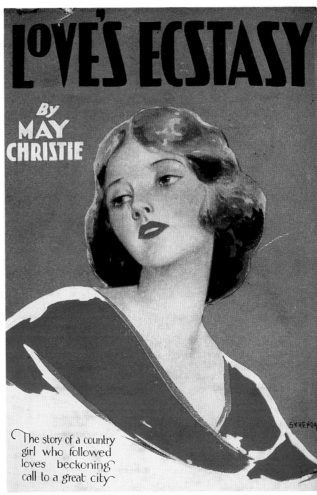

BEAUTY

Grosset & Dunlap, 1933

Designer: Holmgren

The Gilded Age had the Gibson Girl; in the Jazz Age beauty was represented by the idealization on Faith Baldwin's novel.

LOVE'S ECSTASY

Grosset & Dunlap, 1928

Designer: Skrenhoa

This pose seems to have been taken off the *Zelda Marsh* cover. The pretty girl yearning for love was a common visual theme.

PAINTED VEILS
Horace Liveright Inc., 1928
Designer: Paul Wenck

THE ELECTRIC TORCH
G.P. Putnam, 1932
Designer: Bonel

WHITE FAWN
Grosset & Dunlap, 1934
Designer unknown

WALLFLOWERS
Grosset & Dunlap, 1927
Designer: R.P. Coleman

The full-figured woman was only second to the full face in eye appeal.

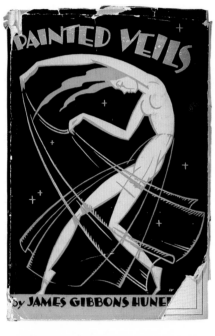

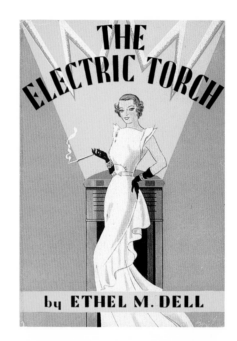

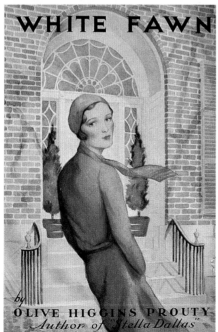

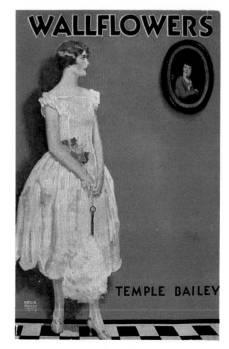

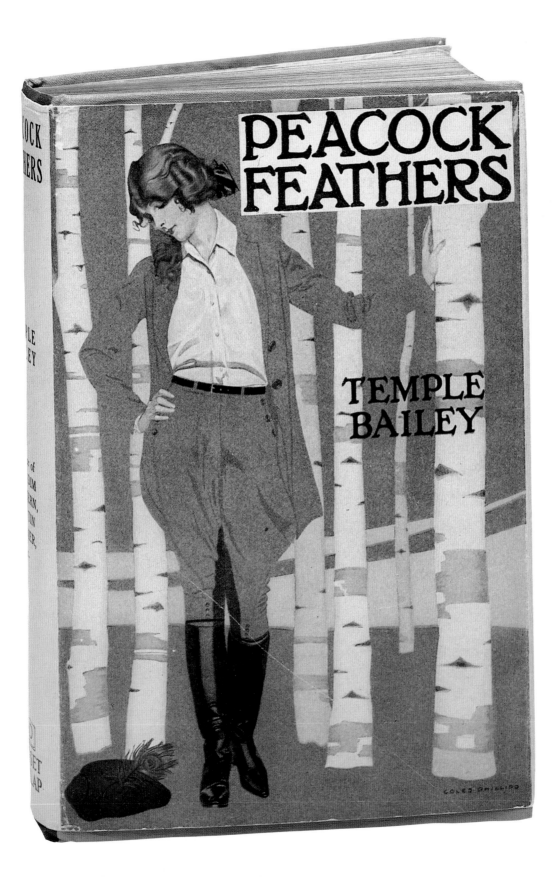

PEACOCK FEATHERS
Grossett & Dunlap, 1924
Designer: Coles Philips

In the early 1900s Coles Philips was one of the top artists of female vignettes — highly stylized, sometimes comic renditions of the idealized American woman.

A PASSIONATE REBEL

A.L. Burt, 1929

Designer: des Rosiers

This enticing tableau of passionate love is replete with lewd suggestion.

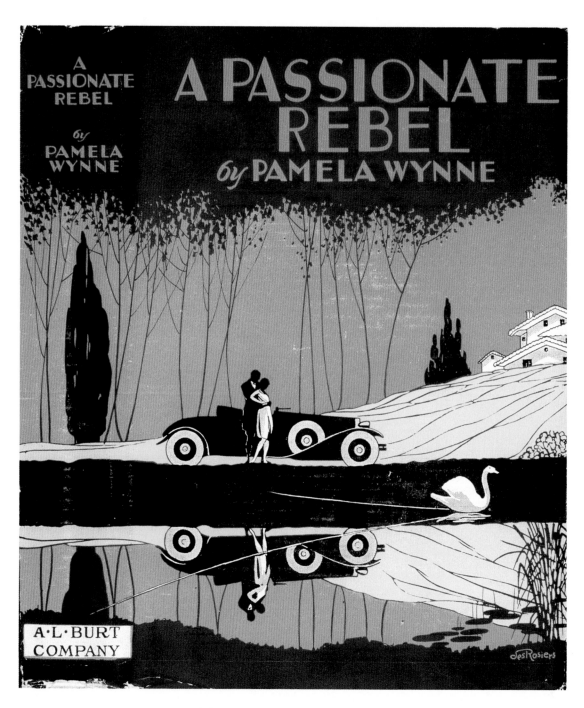

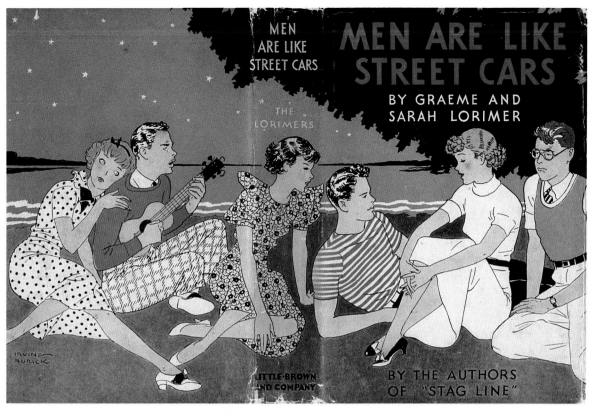

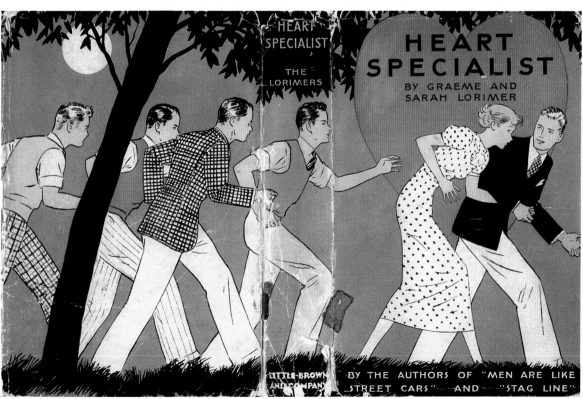

**MEN ARE LIKE
STREET CARS**

*Little, Brown &
Company, 1944*

Designer: Irving Nurick

HEART SPECIALIST

*Little, Brown &
Company, 1945*

Designer: Irving Nurick

In a style reminiscent of
a romance comic book,
Irving Nurick smartly uses
the front and back of the
jacket to evoke the perils
of young love.

**LILY CHRISTINE:
THE STORY OF A
GOOD WOMAN**

*Doubleday Doran &
Company, Inc., 1928*

Designer: Helen Dryden

**NONE BUT THE
LONELY HEART**

The House of Field, c. 1934

Designer: Saunders

THE GYPSY

*Frederick A. Stokes
Company, 1928*

Designer: "J.P."

DEBONAIR

Alfred A. Knopf, 1928

Designer: Ronald McRae

MAKE-BELIEVE

Grossett & Dunlap, 1934

Designer: Arthur Hawkins, Jr.

TOURNAMENT

A.L. Burt Company, 1930

Designer unknown

A single face and exotic
pose; each of these jackets
uses Jazz Age mannerisms
to evoke contemporaneity.

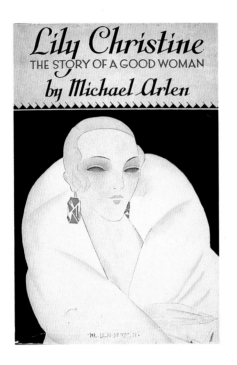

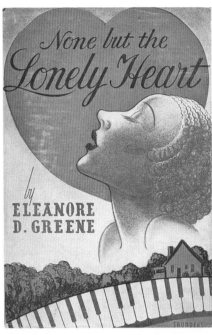

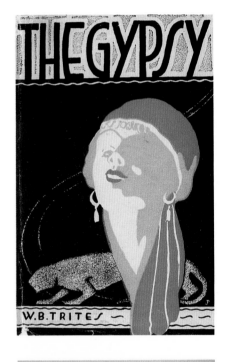

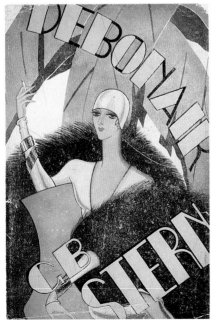

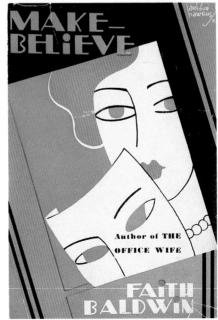

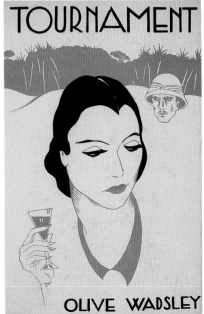

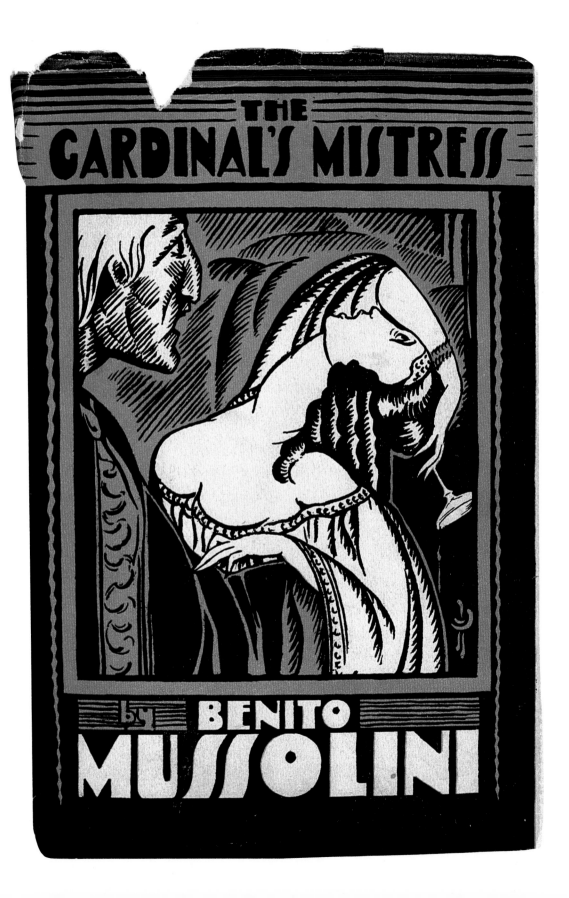

THE CARDINAL'S MISTRESS

Albert & Charles Boni, 1928

Designer unknown

Benito Mussolini's ("Italy's Dictator" as he's described on the flap) first and only novel is designed with a sensational image equal to his sacrilegious subject.

GALLOWS ORCHARD

*Jonathan Cape &
Harrison Smith, 1930*

Designer unknown

One of the sultriest book
jacket faces suggests an
ideal beauty of the time.

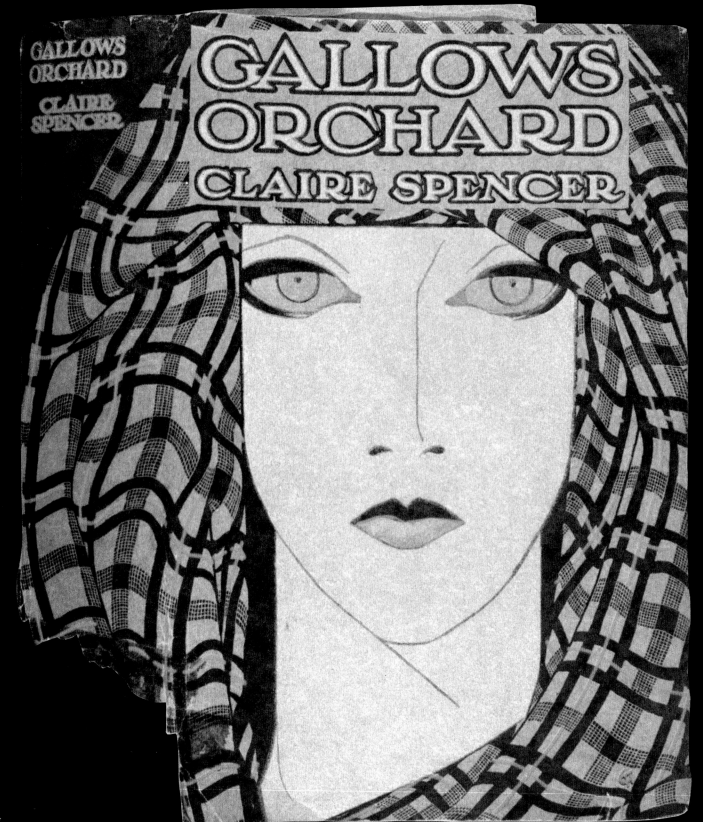

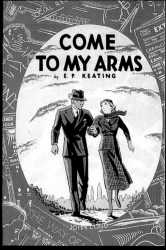

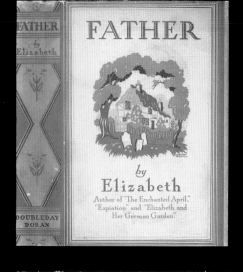

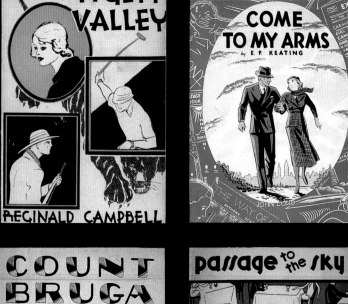

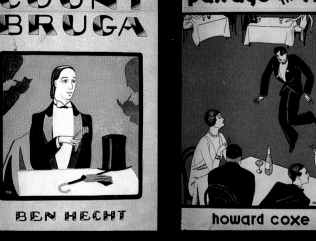

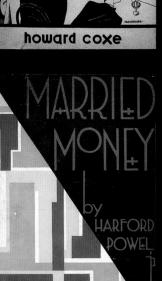

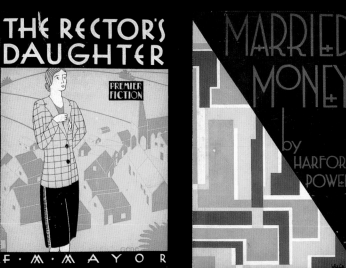

TIGER VALLEY
Richard R. Smith, 1931
Designer unknown

COME TO MY ARMS
Macauly, c. 1936
Designer unknown

FATHER
Doubleday Doran, 1930
Designer: Corydon Bell

COUNT BRUGA
Boni & Liveright, 1926
Designer unknown

PASSAGE TO THE SKY
Boni & Liveright, 1929
Designer unknown

FRUIT OF EDEN
Macaulay Publishers, 1938
Designer unknown

**THE RECTOR'S
DAUGHTER**
Coward McAnn, 1930
*Designer: Eugene (Gene)
Thurston*

MARRIED MONEY
Doubleday Doran, 1930
Designer unknown

SWAN SONG
*Charles Scribner's
Sons, 1928*
Designer: Cleon

From abstraction to styliza-
tion: a variety of ways that
romances were jacketed.

BIRDS GOT TO FLY

Harcourt, Brace & Company, 1929

Designer unknown

Rather than personify the protagonist's "ecstasy," this jacket symbolizes her free spirit.

THE WIFE OF STEFFEN TROMHOLT

Boni & Liveright, 1934

Designer unknown

Among the most common motifs in *art moderne*, the lightning bolt was used to suggest many things. Here the zigzag design is liberally used.

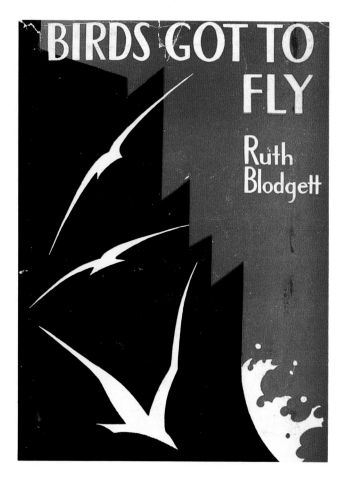

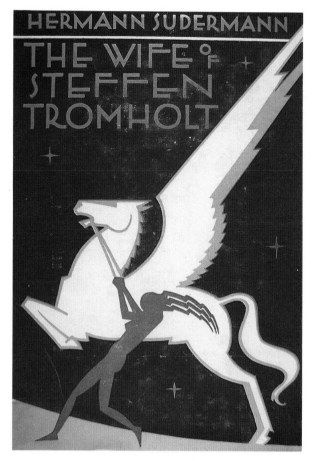

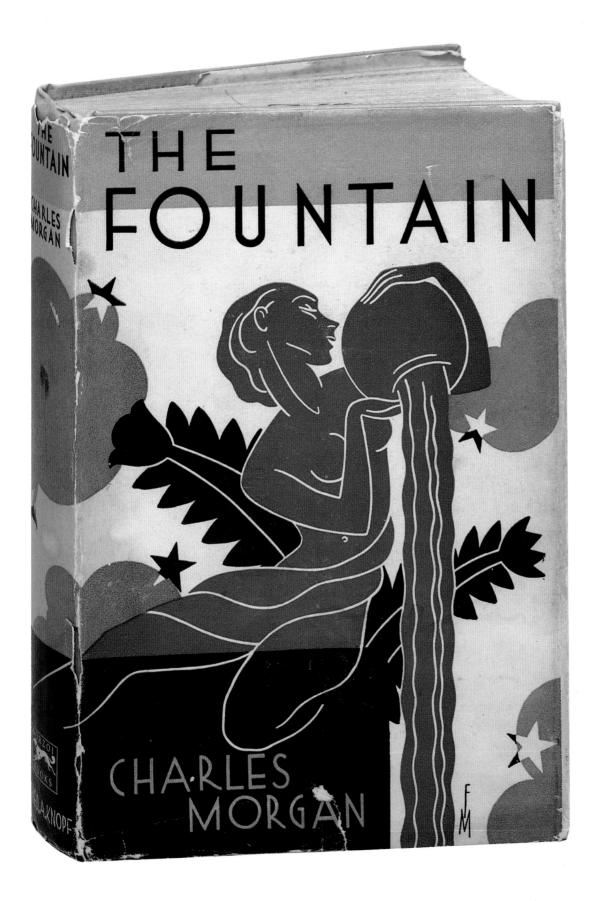

THE FOUNTAIN
Alfred A. Knopf, 1932
Designer: Frank Macintosh
Although Macintosh's elegant line and soothing colors do not really represent the plot, the romantic nature is evoked.

THE STRING
OF PEARLS
A.L. Burt, 1929
Designer: Irving Politzer
Image and lettering are intelligently wed in this romantic comedy.

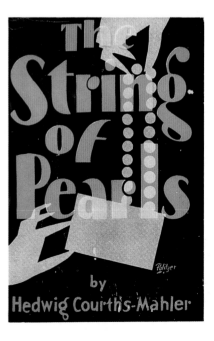











MANNERS

BEGGAR ON HORSEBACK

Boni & Liveright, 1924
Designer: J. Nadejev

The jacket for the book version of a popular Broadway production is replete with silhouettes of the leading players.

THE PLUTOCRAT

Grosset & Dunlap, 1927
Designer unknown

The wraparound image of Tarkington's comedy of manners is not unlike a set designer's sketch for the theater.

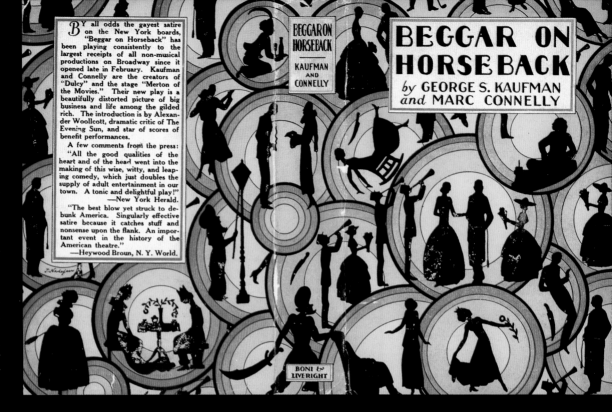

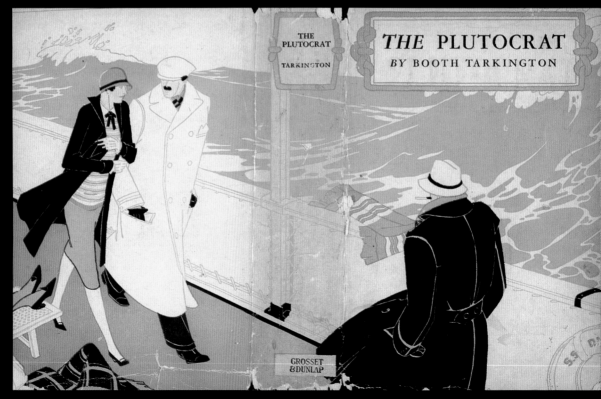

88

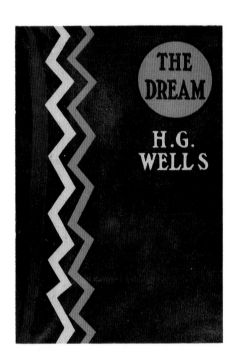

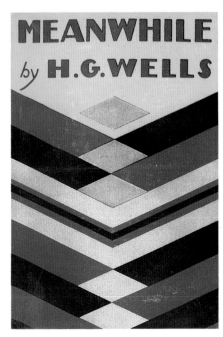

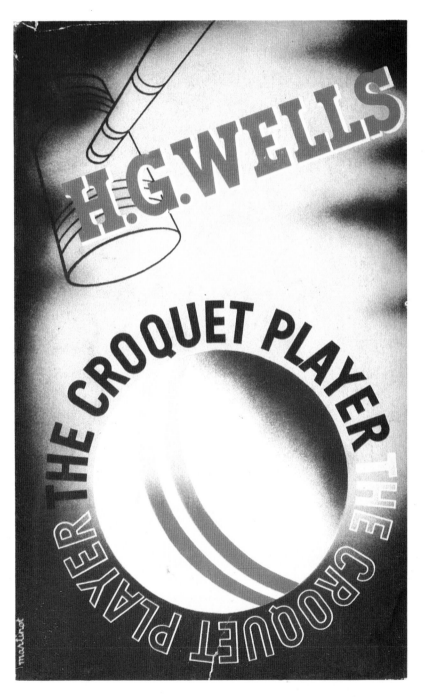

THE DREAM

Publisher unknown, 1924

Designer unknown

Judging from this abstraction, the publisher obviously felt Wells' name was enough to sell his books.

MEANWHILE

George H. Doran Company, 1927

Designer unknown

This decorative design seems more like a binding than a jacket.

THE CROQUET PLAYER

The Viking Press, 1937

Designer: Pierre Martinot

The image illustrates the title, but says little of the plot.

THE CITY WITHOUT JEWS

Bloch Publishing, 1926

Designer unknown

The jacket of this prophetic tale suggests a celebration after Jews were driven out of a great metropolis.

REHEARSAL IN OVIEDO

Knight Publishers, 1937

Designer unknown

Like a Spanish Civil War poster, this jacket echoes the heroic realism of the Communist / Republican forces.

EAST RIVER

Horace Liveright, 1933

Designer unknown

The scene on this tale of urban squalor is informed by the grittiness of the Ash Can School.

MADNESS OF WAR

Harper & Brothers, 1928

Designer unknown

This powerful graphic depicts peace and war, love and hate with the religious overtones.

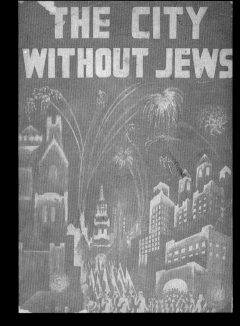

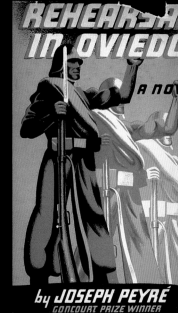

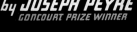

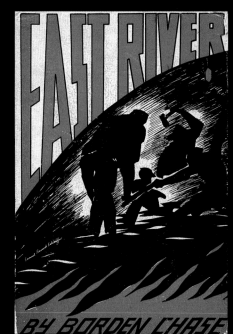

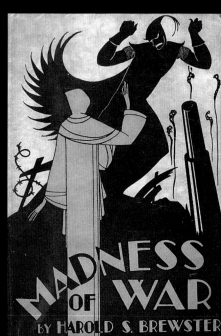

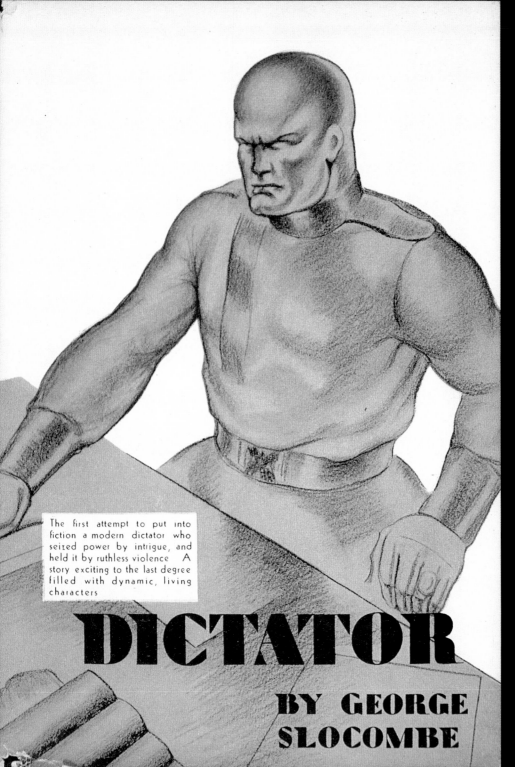

The first attempt to put into fiction a modern dictator who seized power by intrigue, and held it by ruthless violence A story exciting to the last degree filled with dynamic, living characters

DICTATOR

BY GEORGE SLOCOMBE

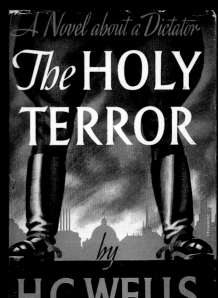

DICTATOR

Houghton Miflin Company, 1933

Designer: Roland Cosimini

While the drawing looks like Italy's Benito Mussolini, the book is the fictional account of a modern dictator. Any similarity to those living is purely coincidence.

THE HOLY TERROR

Simon & Schuster, 1947

Designer: Steinberg

Boots in a menacing pose is enough to evoke the iron-fisted dictator.

A Novel about a Dictator

The HOLY TERROR

by

H.G. WELLS

THE TREE OF LIFE
The Viking Press, 1948
Designer: Boris Artzybasheff

A brilliant draftsman with a keen design sense, Artzybasheff brought wit and elegance to his jacket designs. The color changes on the leaves symbolize the variety of stories therein.

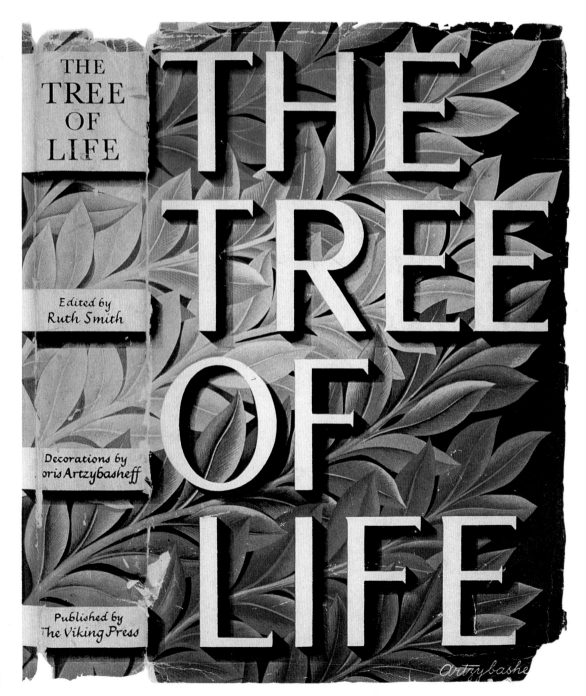

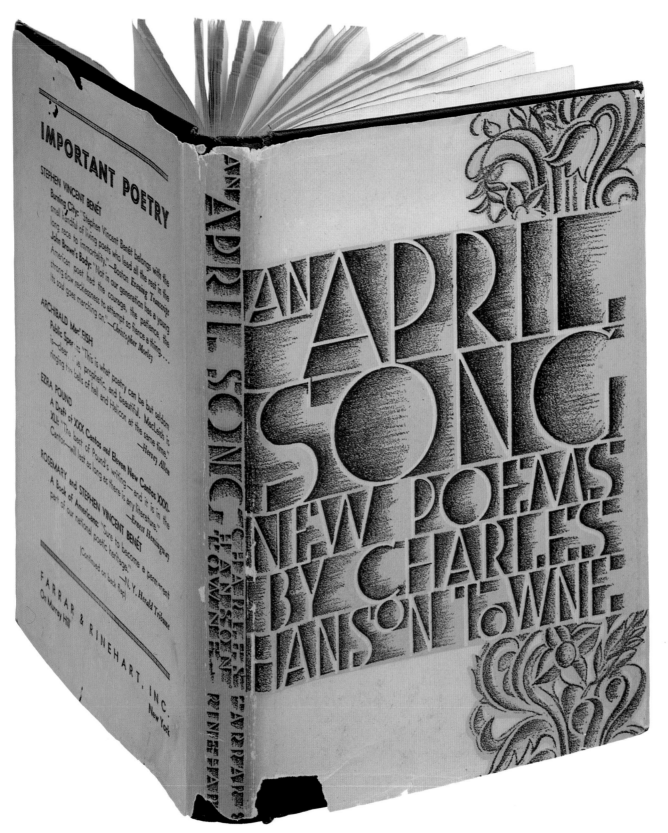

AN APRIL SONG

Farrar & Rinehart, Inc., 1937

Designer unknown

The shadowed lettering and floral decoration were influenced by the advertising designer Gustav Jensen, an influential, but today little known, graphic designer of the 1930s.

(Continued on back flap)

93

A VIKING OF THE SKY

The Saalfield Publishing Company, 1930

Designer unknown

As a rule children's novels were colorfully decorated with type and image.

FARM ON THE HILL

Harcourt, Brace and Company, 1936

Illustrator: Grant Wood

Wood was already a well-known regional painter when he illustrated this book.

SHORT STOP

Grosset & Dunlap, 1932

Designer unknown

Simple jackets for children were often required. Here the baseball diamond frames the player.

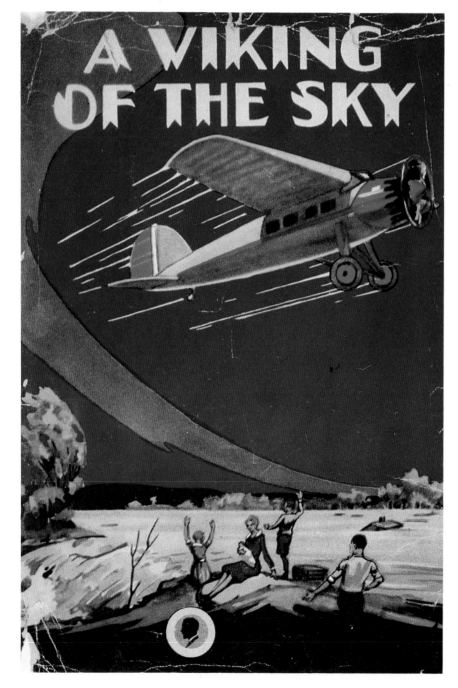

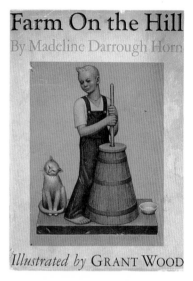

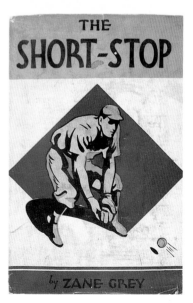

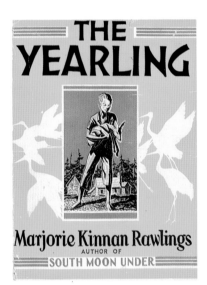

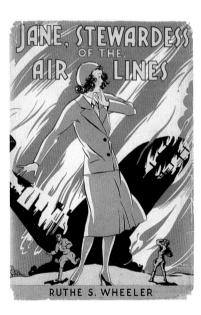

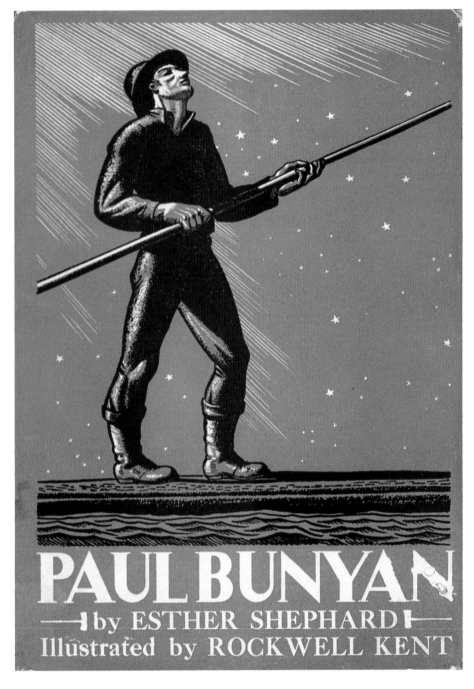

THE YEARLING

Charles Scribner's Sons, 1938

Designer: Edward Shenton

The story of a boy's love for a helpless creature is vivid in this illustration by Edward Shenton.

JANE, STEWARDESS OF THE AIR LINES

The Goldsmith Publishing Company, 1934

Designer: Two Taylors

Against the backdrop of disaster, Jane looks to the heavens for guidance.

PAUL BUNYAN

Harcourt, Brace and Company, 1928

Designer: Rockwell Kent

Few illustrators were as eloquent as Rockwell Kent. His *moderne* styling adds to the Bunyan legend.

**THE ODYSSEY OF
CABEZA DE VACA**

The Century Co., 1934

Designer unknown

A *moderne* interpretation
of the historical figures with
which the designer uses an
indigenous Mexican motif
to frame the title.

HANDS

Farrar & Rinehart, 1930

Designer unknown

The jacket for this "com-
pelling picture of the
American people and their
profound experiences" was
painted in the heroic real-
ism found in the WPA
murals of the day.

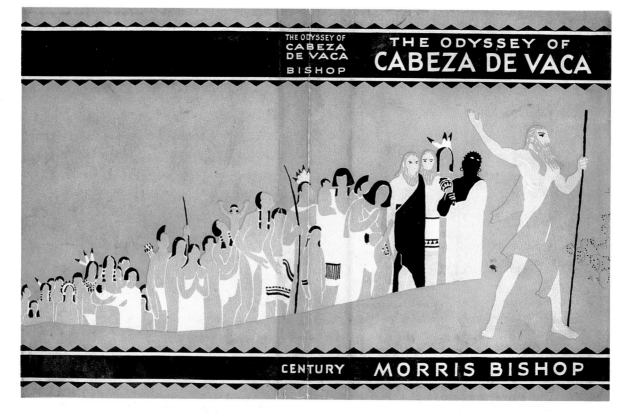

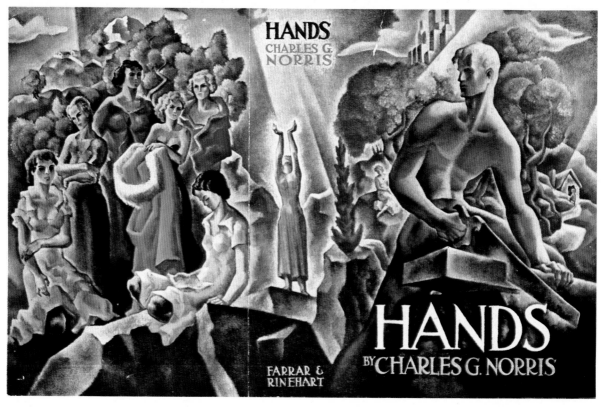

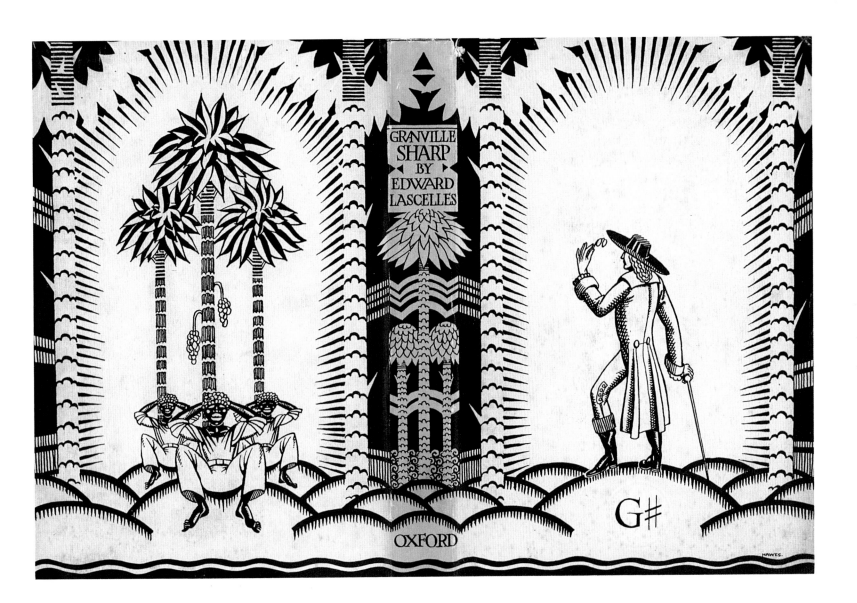

GRANVILLE SHARP

Oxford University Press, 1928

Designer: Hawes

The jacket as triptych; a beautiful rendering.
Note that the title is an abbreviation.

If jackets for fiction appear easy to conceive and design, it is really only by comparison with jackets for nonfiction, which were much more difficult. That publishers allowed artists more license with fiction was only a small part of the story. While it's true that very few nonfiction books from the 1920s, '30s, and '40s are in the pantheon of great jacket design, this is not due simply to the inherent problems in designing for fact as opposed to fiction, but rather because the level of competition for nonfiction books was considerably less than for novels. Publishers placed more emphasis on promoting fiction because novels were issued at a prodigious rate, and furthermore, they were the bread and butter for most publishing houses. They filled the bookseller's shelves and fought for precious window display, and despite the wide range of subjects, fiction was involved in fierce competition not only within its various genres–but with other media as well.

Although nonfiction comprises various genres too, the actual number of books published annually in each category was rarely as high as the fiction categories. The buyers of nonfiction books often knew what they wanted going into the store and did not require the same kind of inducement to stimulate a sale. While this should not mean that the reader did not need to be persuaded—they did—the incentives did not have to be rooted in design. It was reasoned that a biography of a well-known person or a history of a significant period did not require an expressive jacket; it merely had to convey its subject clearly through the jacket's text. In most cases simple calligraphy or typography was sufficient; on many jackets the blurbs were printed on the front to provide even more tangible information. As Charles Rossner states in *The Growth of the Book Jacket*, ". . . jackets for books of this type should impart the scholarly knowledge and competence of the contents . . . From the optical point of view, these book jackets only have to face competition from other books on the same or similar subjects."

Not all publishers were convinced that nonfiction could ostensibly sell itself without help from strong graphics. Some of the more expressive jackets for nonfiction were found on books about politics and social affairs where the complexity of the subject demanded a simple visual interpretation. The jackets for *Red Smoke* and *Moscow Has a Plan*, both commentaries on the future of the Soviet state, had suggestive poster images that evoked the popular perception of the USSR as an industrial power. The jacket for *Stalin* suggested the author's critical posture through an unambiguous picture of the dictator's boots trampling the globe. Similarly suggestive, the jackets for *Bases Overseas* and *Sea Power and Today's War*, both analyses of American military strategy during World War II, were effective in their use of imagery that was more common to war posters than book jackets. Books of this genre were usually typographically uninspiring. Publishers used jackets to prop up nonfiction that might appeal to a fiction buyer: Hence *Last Train from Berlin*, a journalist's firsthand report about Germany before the outbreak of war, was jacketed with a surrealist image that suggests that this is a suspenseful account.

Literary nonfiction, such as memoir and autobiography, were often cross-dressed in fiction's clothes. The jacket for *Dawn*, Theodore Dreiser's autobiography of his younger years, avoids a portrait in favor of what is the quintessence of abstract geometric design —a veritable prefiguration of op art. *Rockwell Kent's Greenland Book: Salamina*, the artist/author's travel journal, was given a jacket that suggests a marriage of analysis and literature. The most eye-catching jackets for nonfiction books could not be differentiated from fiction.

RED SMOKE

National Travel Club, 1932

Designer: Arthur Hawkins, Jr.

In illustrating the title Hawkins evokes a sense of Russia's industrial destiny.

MOSCOW HAS A PLAN

Jonathan Cape, 1931

Designer: William Kermode

The futuristic jacket (repeated on the cover) of this British book published in America evokes the industrial aspirations of the USSR.

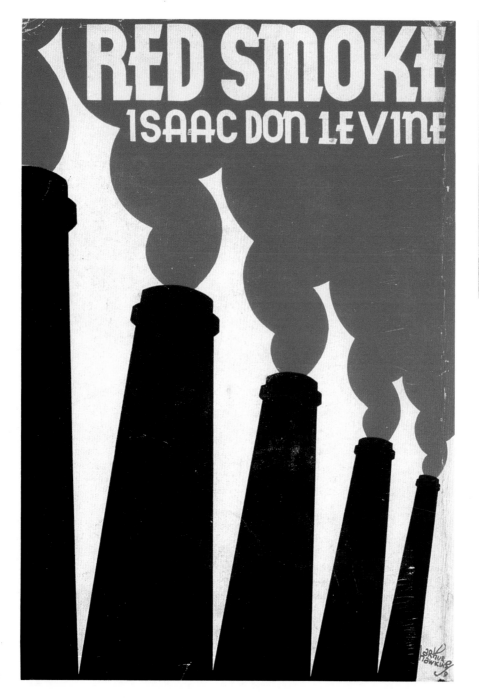

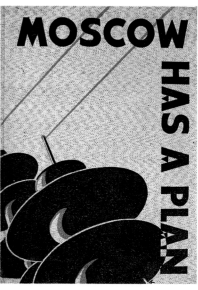

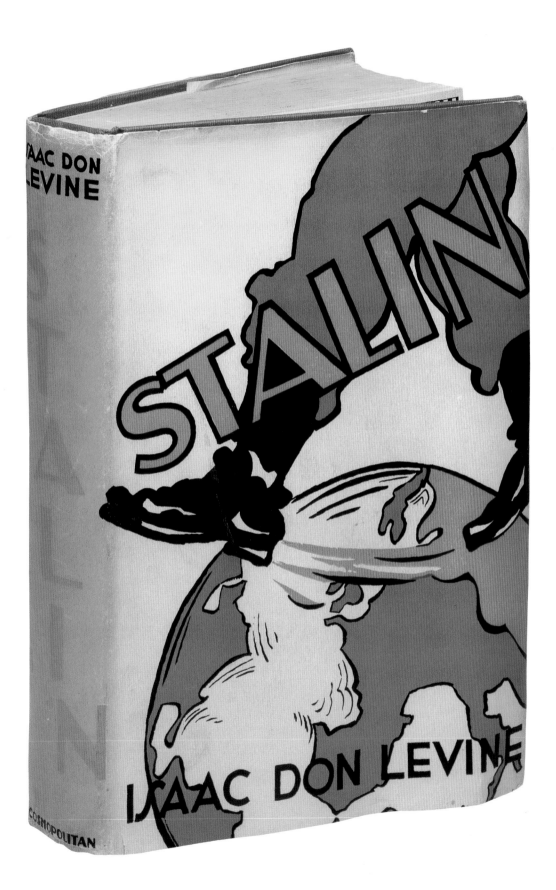

STALIN

Cosmopolitan, 1930

Designer: "U.K."

Boots tramping over the globe is a clear signal that this is not an objective biography.

THE RED NETWORK

Self-published, 1934

Designer: "J.H."

Excessively laden with *au courant* letter forms and a didactic image, this jacket conveys a message the reader cannot mistake.

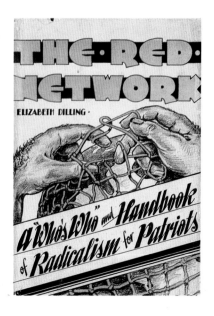

BASES OVERSEAS

*Harcourt Brace and
Company, 1944*

Designer: Arthur Hawkins, Jr.

**SEA POWER AND
TODAY'S WAR**

*Harrison-Hilton
Books Inc., 1939*

Designer: Arthur Hawkins, Jr.

Done before and after the
war, Hawkins's jacket uses
the most recognizable
symbols of defensive and
offensive might.

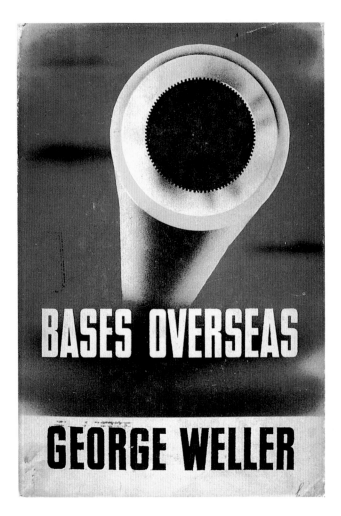

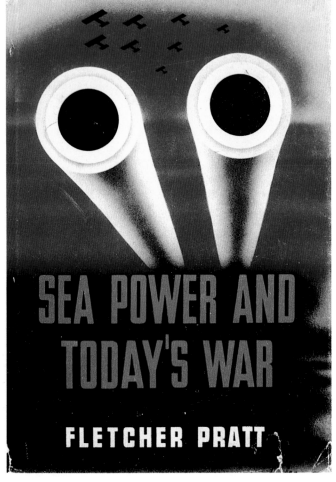

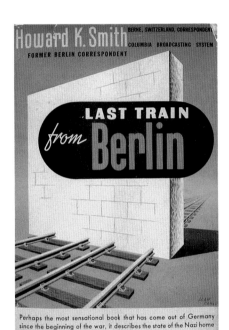

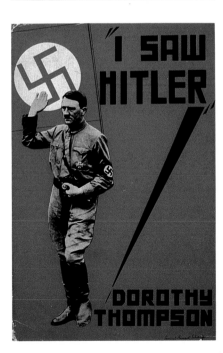

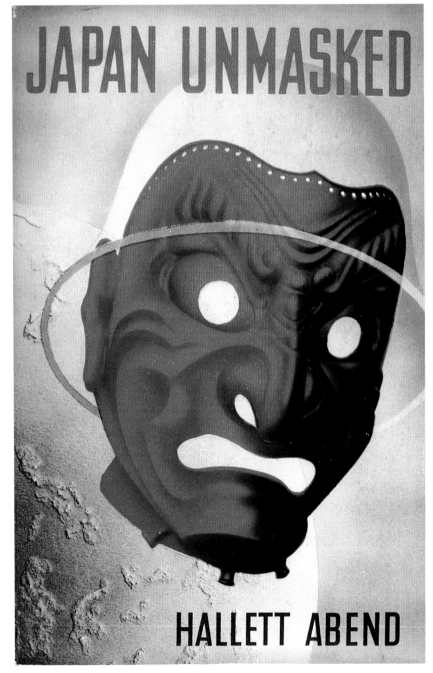

**LAST TRAIN
FROM BERLIN**

Alfred A. Knopf, 1942

Designer: Jean Carlu

Carlu's surrealistic symbolism is apt for this American memoir from the Nazi capital.

I SAW HITLER

Farrar & Rinehart, 1932

Designer: Samuel Bernard Schaeffer

The principles of modern design—collage and asymmetry—are used to introduce this early cautionary note against emerging Nazism.

JAPAN UNMASKED

Ives Washburn, Inc, 1936

Designer: Egri

A likeness of a Japanese mask is used to illustrate this early report on Japan's militaristic goals.

PROPAGANDA

Boni & Liveright, 1928

Designer unknown

Edward Bernays, the "inventor" of public relations, describes how the new media are changing the transmission of ideas and, as the jacket suggests, entangling the public in a web of truisms and falsehoods.

SIZING UP UNCLE SAM

Frederick A. Stokes Company, 1919

Designer: Louis B. Famuller

Through *art nouveau* styling, this image suggests the world's interest in American policy.

BOY AND GIRL TRAMPS OF AMERICA

Farrar & Rinehart, 1934

Designer unknown

This study of poor nomadic American children is illustrated in a gritty Ash Can School manner.

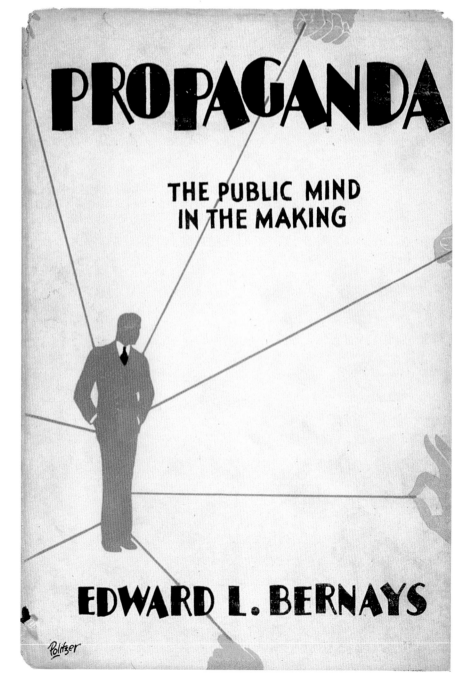

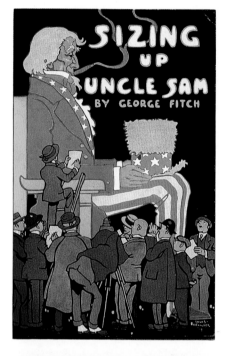

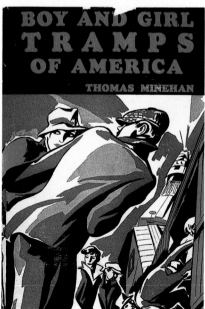

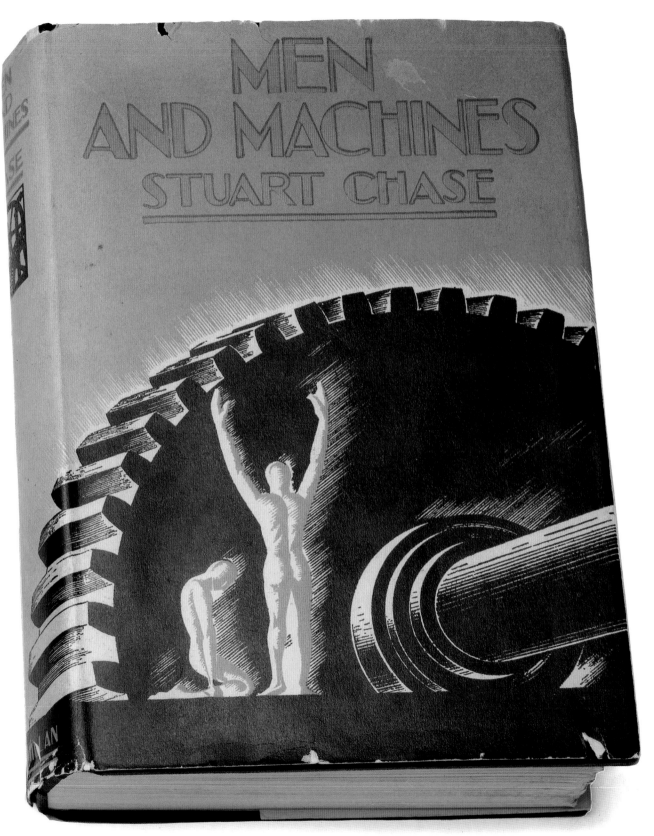

MEN AND MACHINES
Macmillan, 1929
Designer: W.T. Murch
During the Machine Age, man was depicted as being dwarfed by, indeed a slave to, the machine—the idea illustrated by the woodcut illustration on this jacket.

**MAN IN A
CHEMICAL WORLD**

*Charles Scribner's Sons,
1937*

Designer unknown

A fine example of how
otherwise staid, academic
texts were jacketed by
using a mural-like painting
that heroizes scientific
discovery.

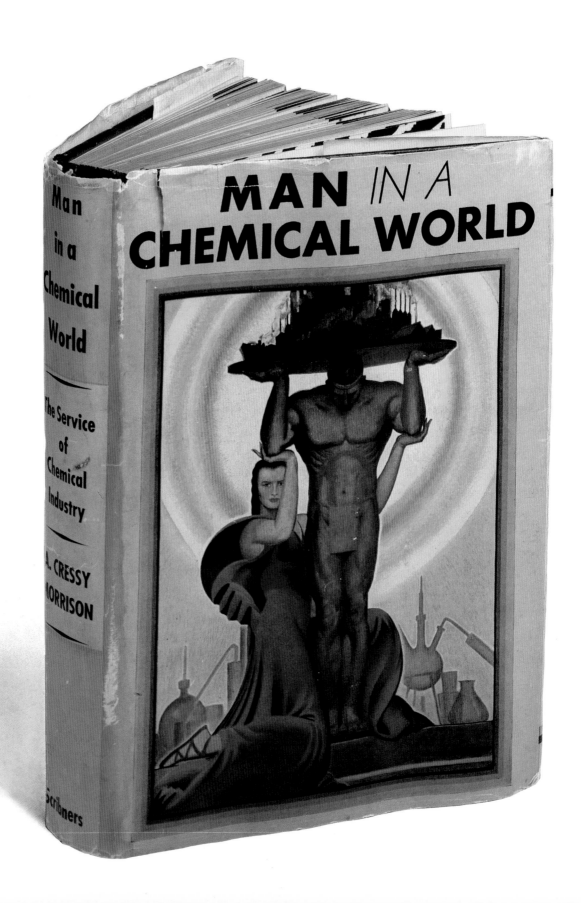

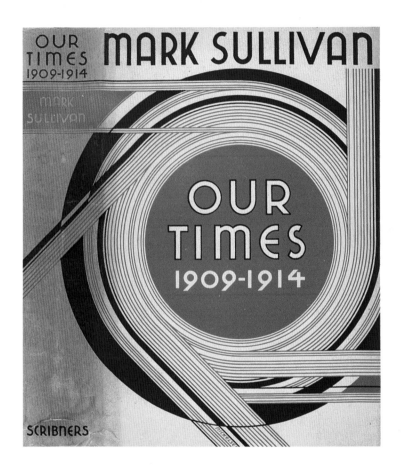

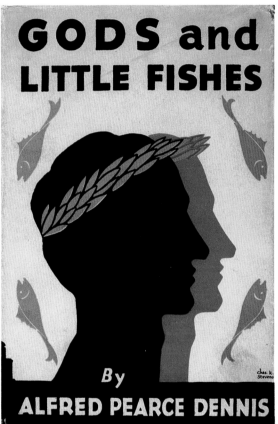

OUR TIMES

Charles Scribner's Sons, 1936

Designer unknown

One jacket for a seminal series of books about the great events of the late nineteenth and twentieth centuries and their impact on America.

GODS AND LITTLE FISHES

Bobbs Merrill and Company, 1931

Designer: Chas K. Stevens

A unique way to illustrate a collection of essays about eminent men.

NOTES OF A VAGABOND
Publisher and date unknown
Designer unknown
This illustration is in the 1930s printmaking tradition that romanticizes the American nomad.

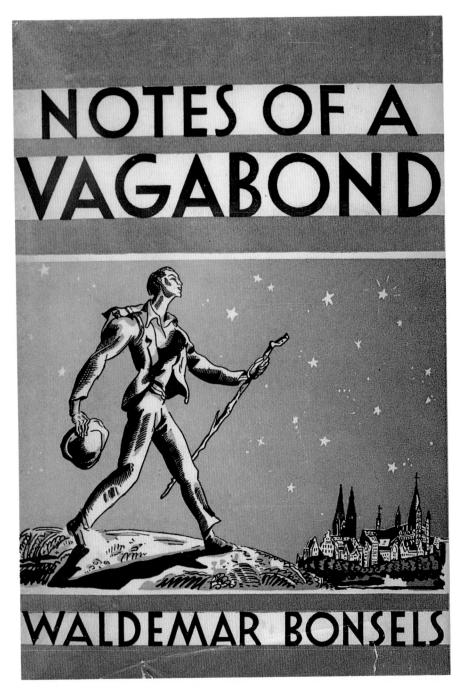

NOTES OF A VAGABOND

WALDEMAR BONSELS

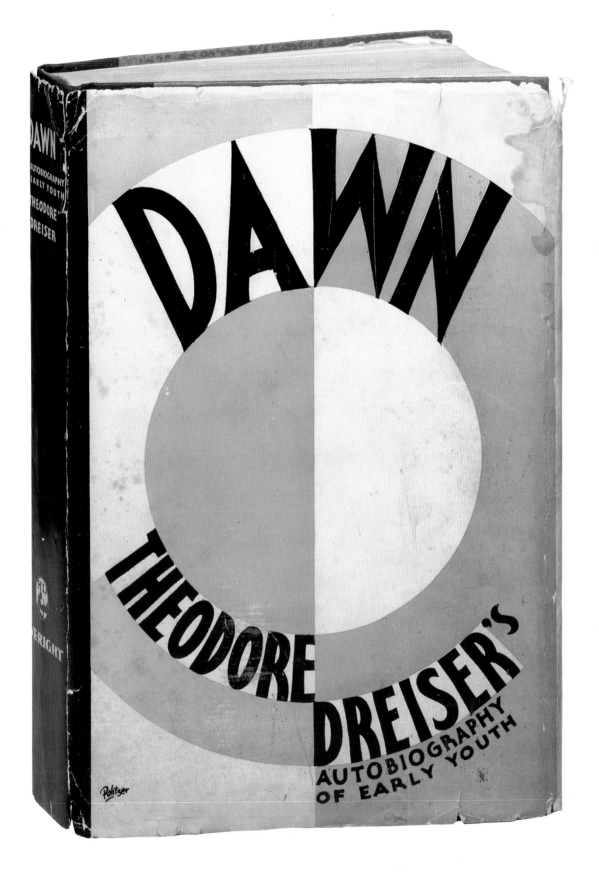

DAWN

Horace Liveright Inc., 1931

Designer: Irving Politzer

Is it a rising sun or an eclipse? Probably neither. The design says little about the book, but provides a bull's-eye for the literary browser.

"WE"

G.P. Putnam, 1930

Designer: "C.K.S."

The sole purpose of this jacket was to make certain the reader knew it was by America's once beloved hero on the occasion of his heroic flight.

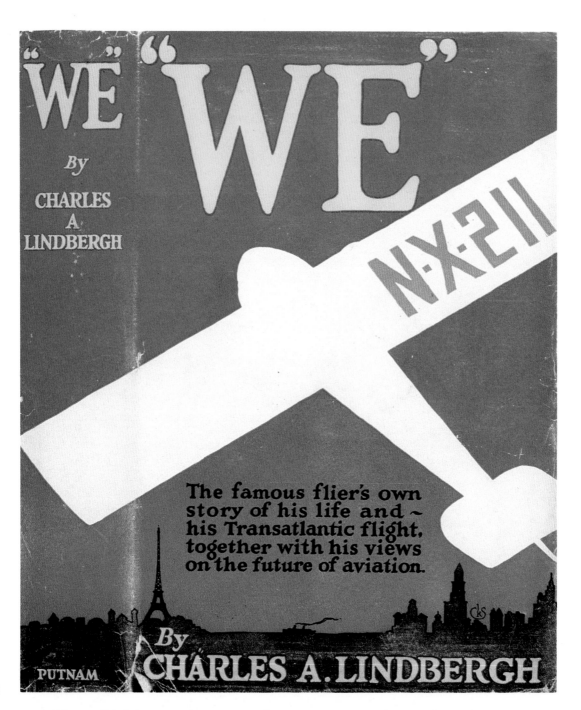

"WE"

By

CHARLES A LINDBERGH

"WE" N·X·211

The famous flier's own story of his life and ~ his Transatlantic flight, together with his views on the future of aviation.

By CHARLES A. LINDBERGH

PUTNAM

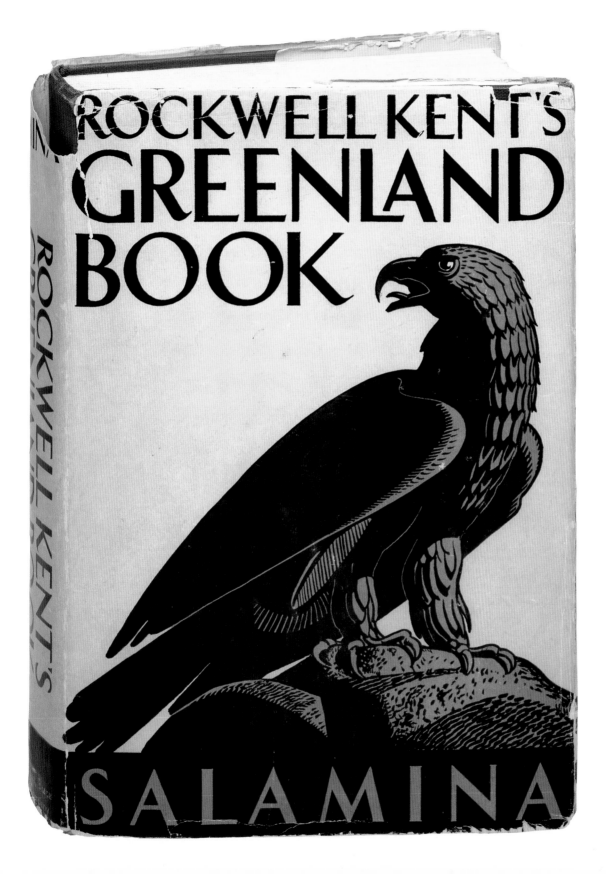

ROCKWELL KENT'S GREENLAND BOOK: SALAMINA

Harcourt, Brace and Company, 1935

Designer: Rockwell Kent

Kent had a talent for isolating the quintessential symbol or icon. For this jacket he decided not to render a landscape, but a heroic eagle to represent his remarkable journey.

HERE'S TO BROADWAY!

G.P. Putnam's Sons, 1930

Designer unknown

This image is a celebration of the Great White Way using many of the graphic motifs common to it.

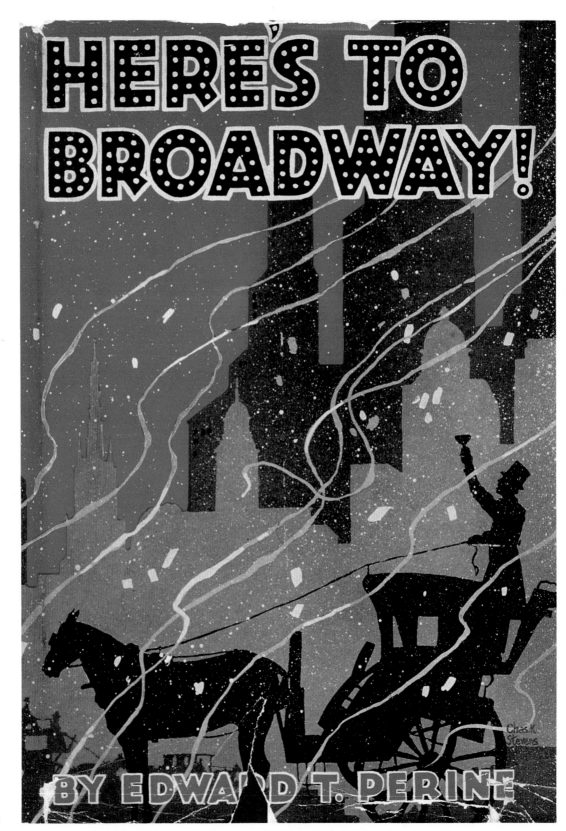

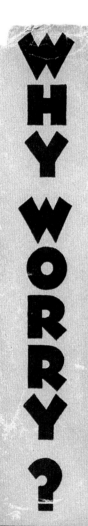

THE LEGS OF THE STORK ARE LONG· THE LEGS OF THE DUCK ARE SHORT ···YOU CANNOT MAKE THE LEGS OF THE STORK SHORT·NEITHER CAN YOU MAKE THE LEGS OF THE DUCK LONG·

WHY WORRY?

WALTON

LIPPINCOTT

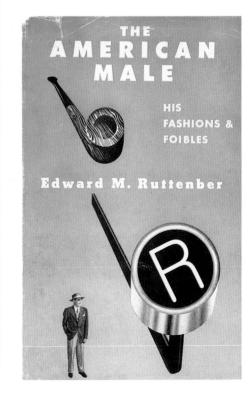

WHY WORRY?
J.B. Lippincott Company, 1932
Designer: "A.W."
A comic style of illustration and lettering is used to introduce a book on pop psychology.

THE AMERICAN MALE
Fairchild Publications Inc., 1948
Designer unknown
Spare, yet symbolic, collage was the hallmark of much modern graphic design like this jacket.

ook jacket designers of the 1920s, '30s, and '40s were recruited from the ranks of commercial art. Most did not devote themselves exclusively to book publishing and were competent in many applied arts. But as the importance of book jackets grew, a few specialists emerged. The field was itself touted as burgeoning in trade magazines and books, drawing to it a range of decorative and realistic artists, stylists, letterers, and calligraphers. Some of them imported and interpreted European approaches; others developed indigenous American mannerisms. Some were loyal to one method regardless of the book's subject; others were general practitioners. Some signed their work; others were prohibited from doing so.

As a rule publishers were notoriously tightfisted. To earn a decent living a jacket designer would have to produce many each season. Low budgets may have accounted for the extreme fluctuation in the quality of jacket design and was also one reason why many designers preferred hand lettering and calligraphy to more expensive typesetting. Until the late 1940s most jacket designers also lettered and illustrated their own jackets. Yet despite the inadequate fees, some designers found the book jacket was a viable testing ground for experimentation.

Among the leading designers are those represented here:

□ *E. McKnight Kauffer* (1880–1954), an American expatriate for over two decades, was an exemplar of modern poster design in England until he returned to New York in 1942. For Kauffer the book jacket virtually replaced the poster, and many of his jackets for Random House's Modern Library and other publishers are economically symbolic and surrealistic against dark backgrounds with block letter titles, not unlike some of his posters.

□ *William Addison Dwiggins* (1880–1956) was one of America's foremost type, lettering, and book designers in the late '20s and '30s. His most distinctive bookmaking achievement was decorative spines featuring his distinctive ornaments. Though a reluctant jacket designer (he agreed that the jacket was not an integral part of the book), he nevertheless created many jackets using calligraphy that defined an American style and influenced other designers.

□ *George Salter* (1897–1967), an esteemed jacket designer in Germany during the early 1930s, was called the "master of airbrush" in the '40s by his colleagues in America for the impressionistic imagery that was frequently wed to his distinctive calligraphy. Although Salter was not tied to a signature style, his method was unmistakable.

□ *Arthur Hawkins, Jr.* (1903–1987) was an illustrator whose career in publishing, which began in the 1920s, includes the design of over 1500 jackets.

He was a *moderne* stylist whose strength was in combining both symbolic illustration and decorative lettering. Owing to poor fees he eventually became an outdoor advertising art director before returning to publishing as a designer of promotional materials.

□ *Alvin Lustig* (1915–1955) changed the look of book jackets in the mid '40s through his practical application of Modern Art and Modern typography. Lustig introduced photomontage to American jackets as a means of giving the two-dimensional surface a three-dimensional illusion. His series of illustrated jackets for New Directions Classics took the abstraction of Miro, Mark Rothko, and others to the limits of applied art.

□ *Paul Rand* (1914–), a leading American advertising, magazine, and later, corporate designer in the late '40s, used the book jacket as a canvas. His jackets rejected the overly rendered and airbrushed illustrative and calligraphic methods and favored the bold modern typography and photographic illustration that were often conceptual, communicated through wit and humor.

These designers created jackets that, viewed through the historical lens, define their times. Both an elegant simplicity and virtuosic complexity helped to define and promote the books, but also set a standard for American graphic design.

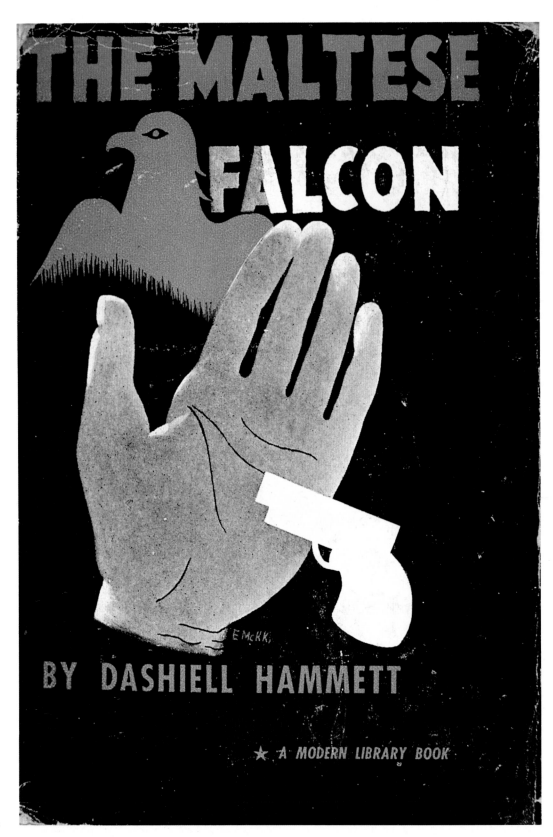

E. MᶜKNIGHT
KAUFFER

THE MALTESE FALCON
The Modern Library, c. 1947
Kauffer frequently designed
for Random House's The
Modern Library which
reprinted low-cost editions
of modern classics. Given
the small size of these
books, Kauffer usually
illustrated the plots using a
symbolic shorthand.

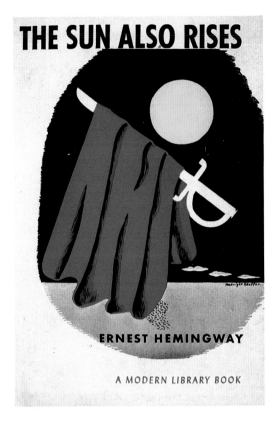

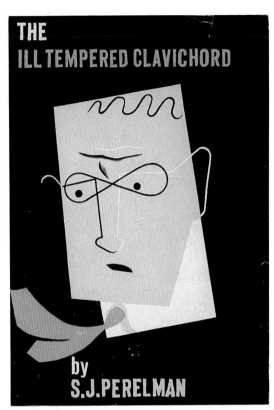

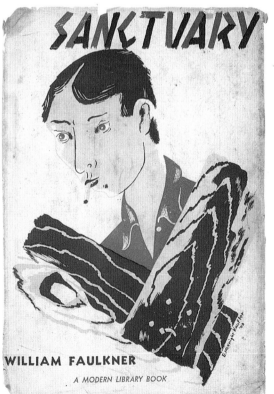

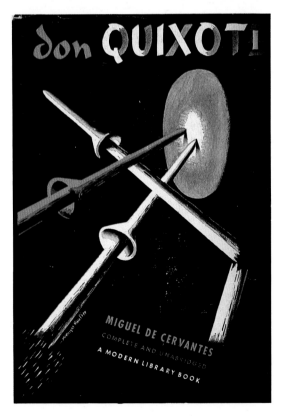

THE SUN ALSO RISES
The Modern Library,
c. 1948

THE ILL TEMPERED
CLAVICHORD
Simon and Schuster, 1950

SANCTUARY
The Modern Library, 1949

DON QUIXOTE
The Modern Library, 1948

Kauffer usually rendered
these small format jackets
in an economical, symbolic
poster style.

117

**THE AUTOBIOGRAPHY
OF A SUPER TRAMP**

Alfred A. Knopf, 1938

SERENADE

Alfred A. Knopf, 1937

Dwiggins was known for his unique graphic ornaments that served as a bridge between *art nouveau* and *art moderne*, and were influenced by South American and Asian motifs. His bindings (especially the spines) were beautifully adorned. His jackets were more colorful and, at times, gaudy.

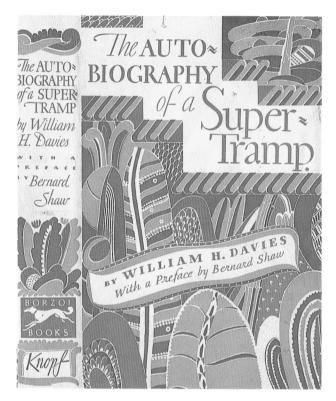

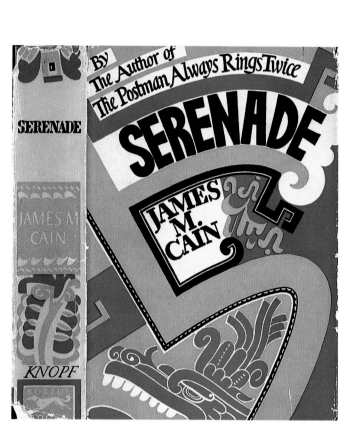

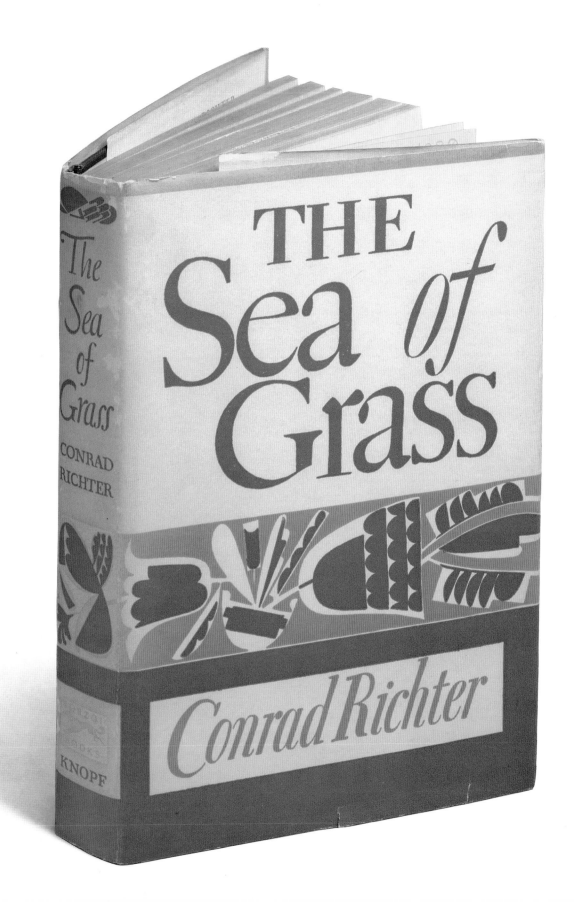

THE SEA OF GRASS
Alfred A. Knopf, 1937
Dwiggins was a master of lettering. All his jackets were hand lettered, sometimes to echo his own typefaces used inside the book.

**ROBERT NATHAN'S
THE BARLY FIELDS**

Literary Guild, 1934

**THE BOMB THAT
WOULDN'T GO OFF**

BH, 1934

**LAYOUT IN
ADVERTISING**

Harper & Brothers, 1928

THE BORZOI READER

Alfred A. Knopf, 1935

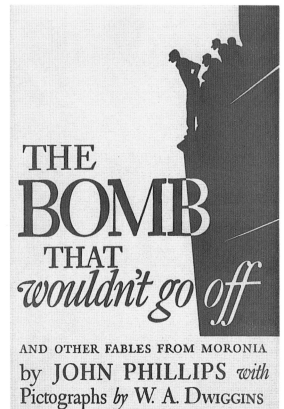

LAST AND FIRST MEN

Jonathan Cape and Harrison Smith, 1931

The jacket for this "story of the near and far future," with its multiple worlds shooting from the heavens, is rendered in a futuristic manner that was influenced by *art moderne*.

SANCTUARY

Jonathan Cape
Harrison Smith, 1931

SARTORIS

Jonathan Cape
Harrison Smith, 1929

DOCTOR MARTINO

Harrison Smith
Robert Haas, c. 1930

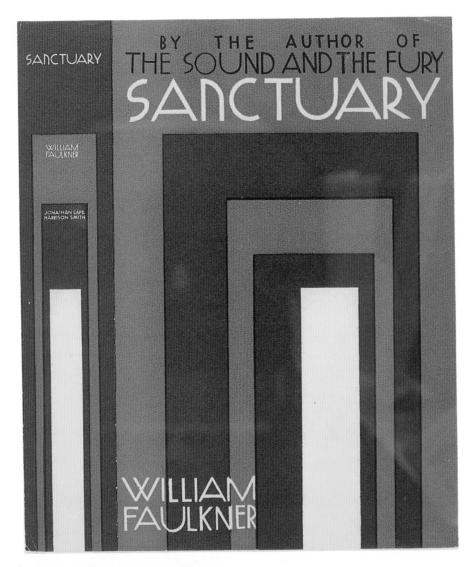

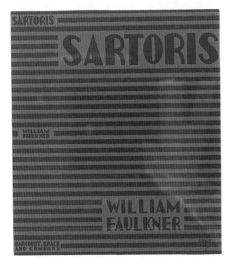

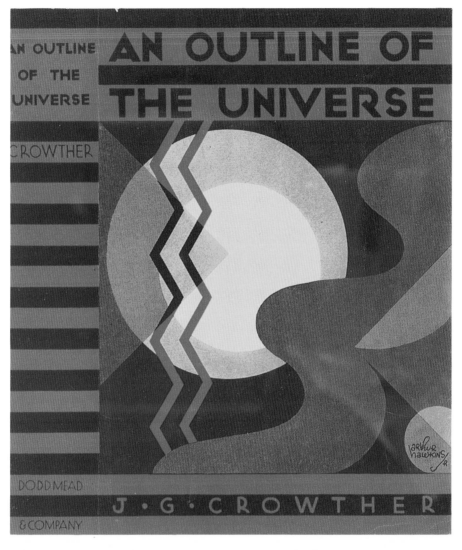

**AN OUTLINE OF
THE UNIVERSE**

*Dodd Mead and Company,
c. 1932*

**THEY WERE STILL
DANCING**

*Jonathan Cape
Harrison Smith, 1932*

**THE POSTMAN
ALWAYS RINGS TWICE**

Alfred A. Knopf, 1933

These early Hawkins jackets
were based on geometric and
abstract design rather than
illustration, and these were
among the most eye-catching
of the *art moderne* designs.

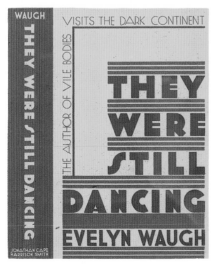

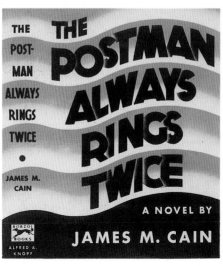

**MURDER ON
THE PALISADES**

Robert M. McBride, 1936

In this early jacket Hawkins
compresses the cover image
to suggest great heights.

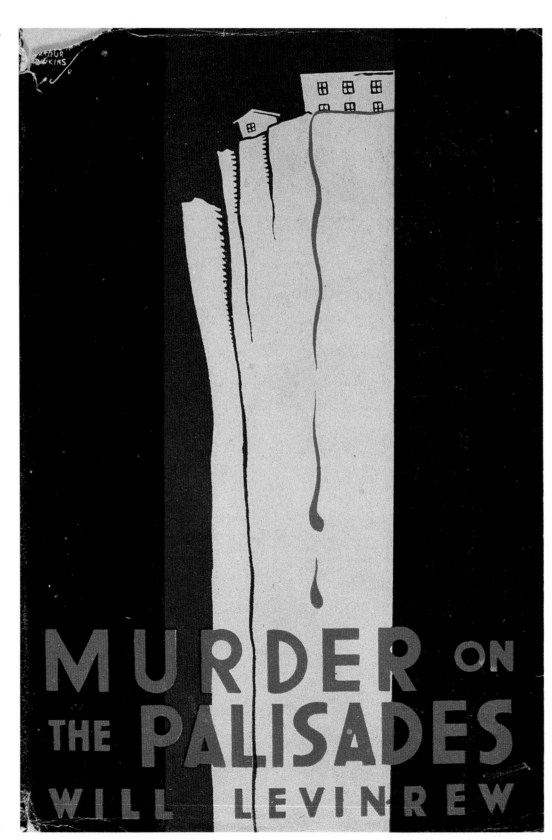

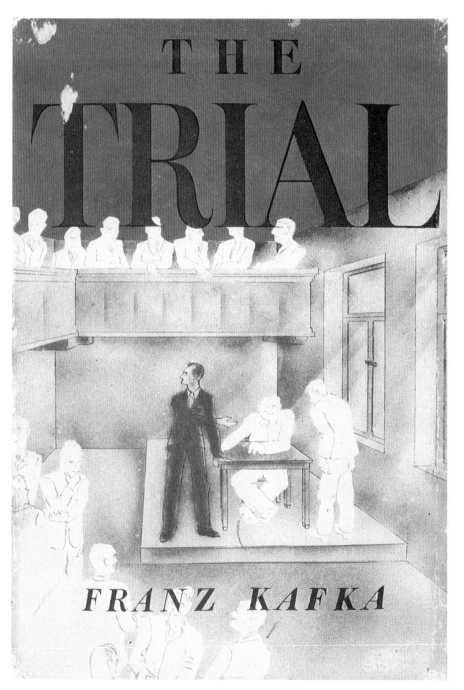

THE TRIAL
Alfred A. Knopf, 1937

THE BAROTIQUE MYSTERY
Walter J. Black, 1947

MURDER WITH PICTURES
Walter J. Black, 1947

Of all Salter's jackets, the one for Franz Kafka's *The Trial* is the most well-known, not for its ubiquity (it was reprinted for various editions), but for its beguiling ironic simplicity. This simple scene suggests an uncertain calm in the face of a bureaucratic nightmare.

MIRACLE IN BRITTANY

Alfred A. Knopf, 1946

**JUGGERNAUT
OVER HOLLAND**

Columbia, 1945

Salter emigrated to the
United States from Ger-
many where he had been a
successful Modern jacket
designer with a distinctive
style. In America he became
a generalist. Although he
took different tacks with
each project, he was expert
at airbrush and calligraphy.

126

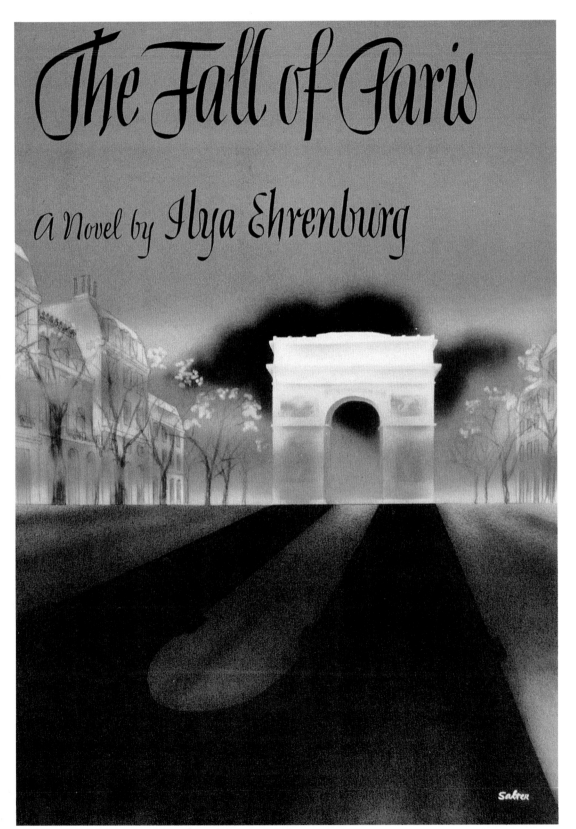

GEORGE SALTER

THE FALL OF PARIS
Alfred A. Knopf, 1943

ATLAS SHRUGGED
Random House, 1957

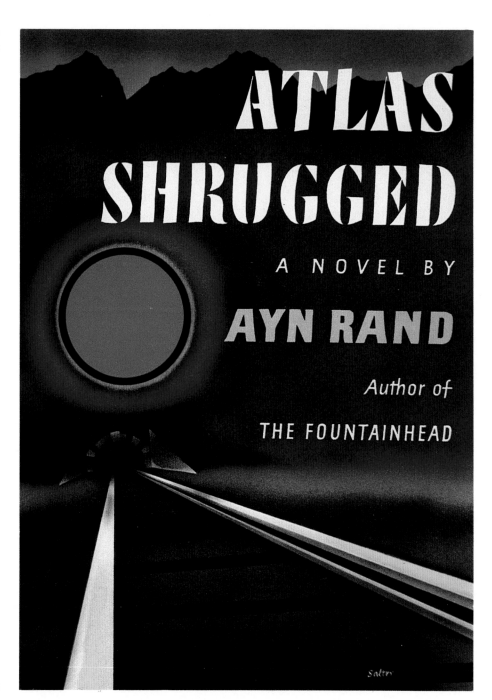

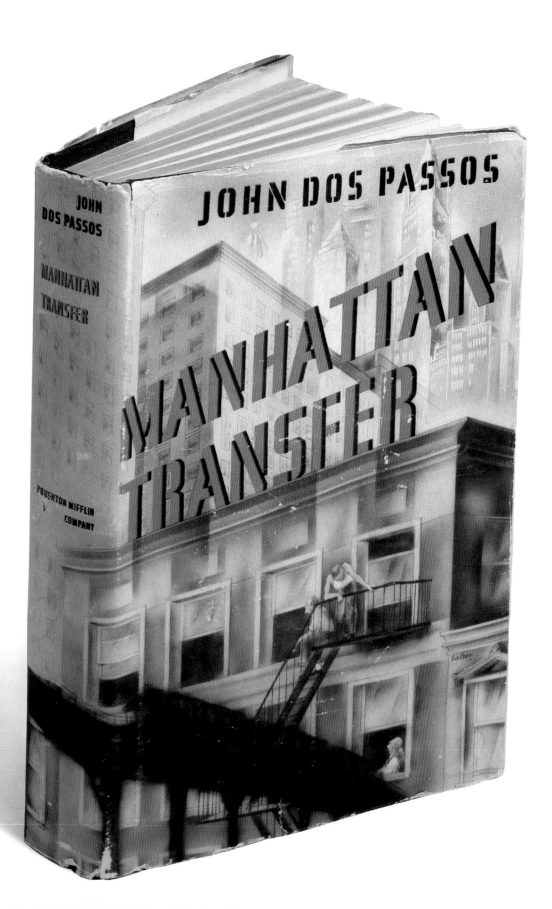

MANHATTAN TRANSFER

Houghton Mifflin Company, 1946

The jacket takes its view from inside a window looking out at the bold cityscape. The title reads as if a sign atop the tenement roof.

ALVIN LUSTIG

A ROOM WITH A VIEW
New Directions, 1947

THREE TALES
New Directions, 1946

Lustig's jackets were
allowed to test the limits of
book jacket imagery for
New Directions, for whom
he designed jackets using
abstract, art-based images

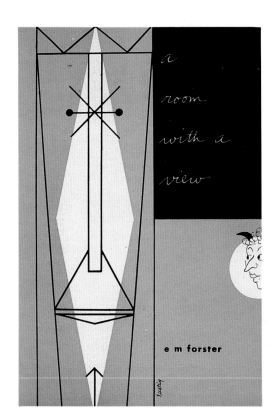

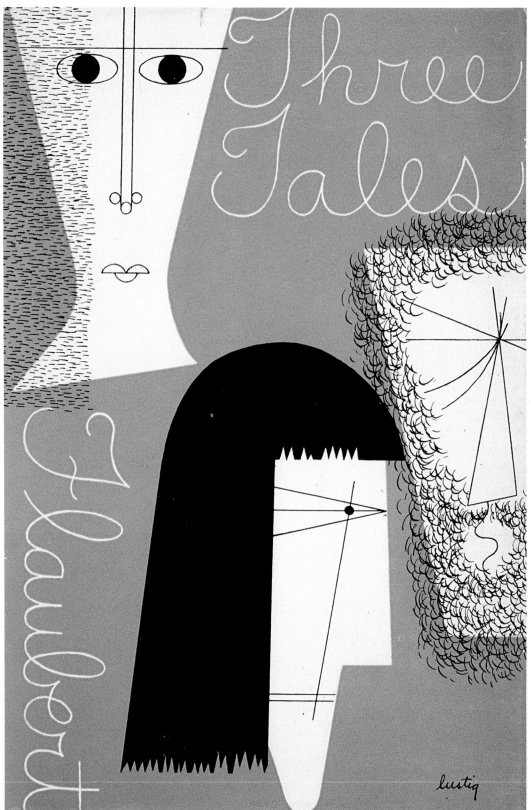

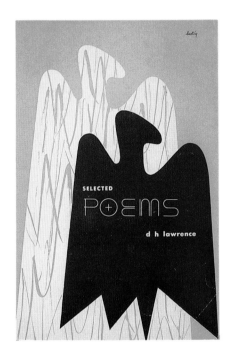

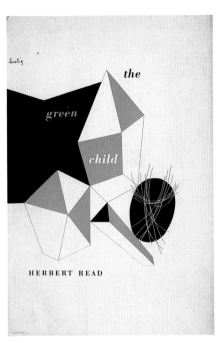

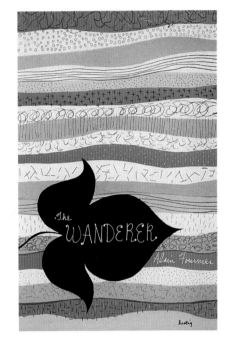

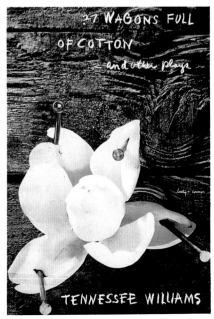

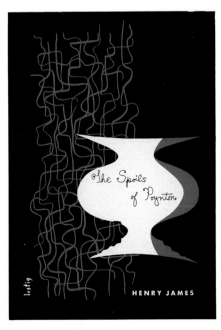

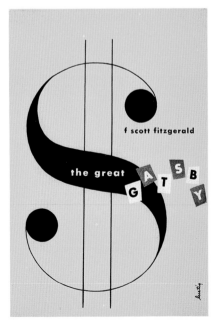

POEMS
New Directions, 1948

THE GREEN CHILD
New Directions, 1948

THE WANDERER
New Directions, 1946

**27 WAGONS FULL
OF COTTON**
New Directions, 1949

**THE SPOILS
OF POYNTON**
New Directions, 1947

THE GREAT GATSBY
New Directions, 1948

ALVIN LUSTIG

NIGHTWOOD

New Directions, 1947

SELECTED POEMS OF KENNETH PATCHEN

New Directions, 1946

FLOWERS OF EVIL

New Directions, 1947

THE LONGEST JOURNEY

New Directions, 1947

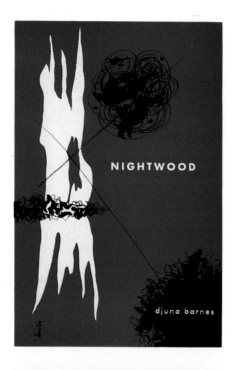

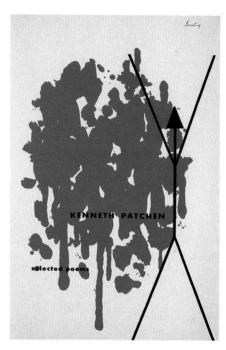

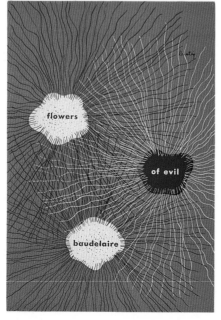

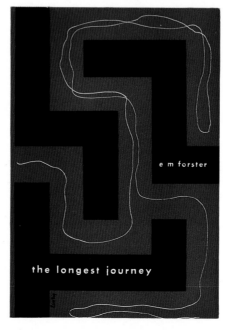

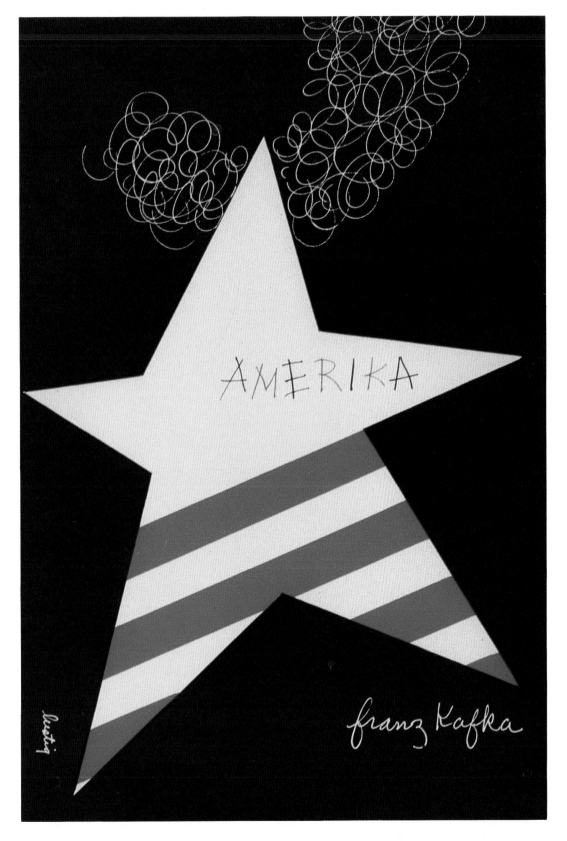

AMERIKA

New Directions, 1948

Compared to the German edition of Kafka's classic, which showed a dramatic panorama of New York, Lustig chose to use a childlike star from which emanates squiggles of smoke.

EXILES
New Directions, 1947

**A STREETCAR
NAMED DESIRE**
New Directions, 1946

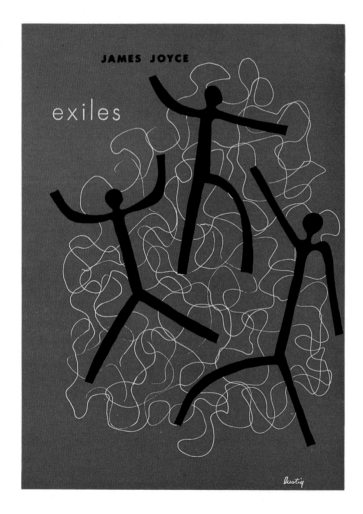

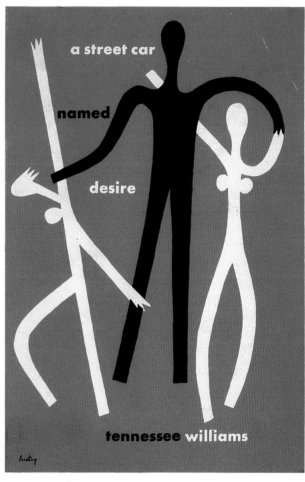

THE MAN WHO DIED

d h lawrence

THE MAN WHO DIED
New Directions, 1946
Lustig not only created a
personality for the New
Directions Classics, he
advanced the standard of
book jacket design through
his use of abstract images,
often combined with
modern typography. The
jackets here suggest the
influences of painters
such as Miro, Picasso,
and Rothko.

**THE CONFESSIONS
OF ZENO**

New Directions, 1947

MISS LONELYHEARTS

New Directions, 1946

Collage and montage were
among Lustig's contribu-
tions to American book
jacket design. His photo
jackets, informed by John
Heartfield's jackets for the
German publisher, The
Malik Verlag, were master-
pieces of conceptual acuity
— almost always done in
black and white.

THOUGHTS ON DESIGN
Wittenborn, 1946

**ORIGINS OF
MODERN SCULPTURE**
Wittenborn, 1946

DADA
Wittenborn, 1950

Paul Rand introduced
modern principles to book
jacket design. His work
was design, not illustration.
Typography, as opposed to
the calligraphy in vogue at
the time, was wed to image,
usually photography.
Photograms, collage, and
montage were his media.
Even today, the jackets
he designed in the 1940s
have a timeless quality
because the images he
used were not rooted in a
style or time period, and
the typography was not
novel, but functional.

**THE STORK CLUB
BAR BOOK**

Alfred A. Knopf, 1947

THE FERVENT YEARS:

**THE STORY OF THE
GROUP THEATER AND
THE THIRTIES**

Alfred A. Knopf, 1945

**THE TABLES OF
THE LAW**

Alfred A. Knopf, 1943

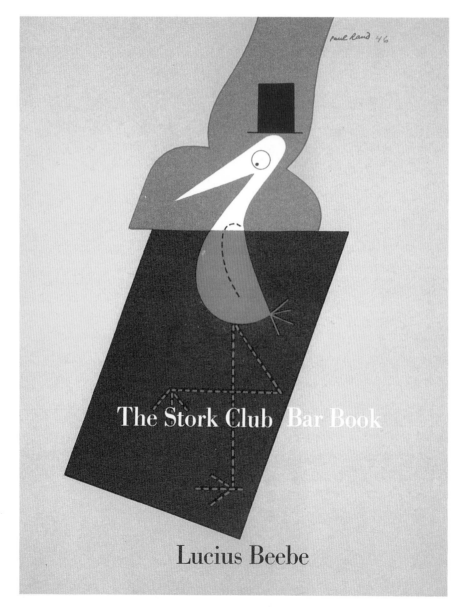

leave
cancelled
by nicholas
monsarrat

LEAVE CANCELLED
Alfred A. Knopf, 1945
This love story about a
soldier's return to the front
is unconventionally repre-
sented with an angel/cupid
(representing love) and die
cut "bullet" holes suggest-
ing the book's wartime
setting. Yet nothing about
the design of this jacket
reveals the time period in
which it was produced.
So timeless is the composi-
tion, it could have been
designed today.

John T. Winterich, *Collector's Choice*;
Greenberg Publisher, New York, 1928.

John Tebbel, *A History of Book Publishing
in the United States: Volume III The Golden
Age Between Two Wars 1920–1940*; R.R.
Bowker Company, New York, 1978.

Charles Rosner, *The Growth of the Book
Jacket*; Harvard University Press,
Cambridge, Massachusetts, 1954.

Piet Schreuders, *Paperbacks, A Graphic
History, 1939–1959;* Blue Dolphin Enter-
prises, Inc., San Diego, California, 1981.

*75 Years or The Joys and Sorrows of
Publishing and Selling Books At Duttons
from 1852–1927;* E.P. Dutton, 1927.

Helen Dryden, "Literary Cloaks and Suits"
in *Advertising Arts*, New York City,
July 1931.

*First Annual Exhibition Book Jacket
Designers Guild* 1948. A-D Gallery,
New York, 1948.

*Second Annual Exhibition Book Jacket
Designers Guild* 1949. A-D Gallery,
New York, 1949.

Steven Greengard, "Cover Story," *Journal of
Decorative and Propaganda Arts*, No. 7,
Miami, Florida, Winter 1988.

Marshall Lee, *Books for Our Times*;
Oxford University Press, New York, 1952.

*Commercial Design: The Textbook of Art
Illustration Inc.*, Minneapolis, Minnesota,
1948.